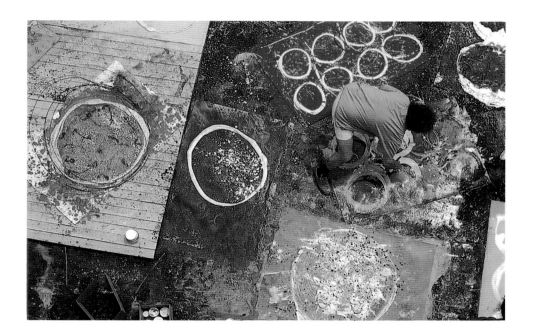

CHIHULY

FORM FROM FIRE

ESSAYS BY

WALTER DARBY BANNARD

HENRY GELDZAHLER

THE MUSEUM OF ARTS AND SCIENCES, INC., DAYTONA BEACH
IN ASSOCIATION WITH
UNIVERSITY OF WASHINGTON PRESS

For my brother Italo

EXHIBITION SCHEDULE

Lowe Art Museum, University of Miami, Coral Gables, Florida
January 28 – March 28, 1993

Tampa Museum of Art, Tampa, Florida
May 1 – August 21, 1993

Museum of Arts and Sciences, Daytona Beach, Florida
September 11 – November 28, 1993

Philharmonic Center for the Arts, Naples, Florida
December 7, 1993 – February 2, 1994

Samuel P. Harn Museum of Art, University of Florida, Gainesville, Florida
February 19 – June 12, 1994

Florida State University Gallery & Museum, Tallahassee, Florida
August 29 – September 25, 1994

Center for the Arts, Vero Beach, Florida
September 17 – December 15, 1994

St. John's Museum, Wilmington, North Carolina
January 12 – February 26, 1995

Chihuly: Form from Fire

Published by Portland Press and The Museum of Arts and Sciences, Inc., Daytona Beach, Florida,
with support from the National Endowment for the Arts, Florida Arts Council
and Chapman J. Root, II, in association with the University of Washington Press.
"Dale Chihuly" by Holland Cotter copyright ©1993 by *The New York Times*
Copyright ©1993 by Dale Chihuly

ISBN 0–933053–06–1

Exhibition coordinated by Karen S. Chambers
Designed by Katy Homans and Sayre Coombs
Printed and bound by C&C Offset Printing Company, Hong Kong
Photo Credits: Dick Busher, pp. 18-19, 28-29, 32-33, 58; Eduardo Calderon, pp. 65, 75, 90-91,
93-97, 112; John Gaines, pp. 88-89, 115; Claire Garoutte, pp. 20, 22-23, 25, 48, 56-57,
59-61, 67, 74, 77, 80-81, 87, 103-107, 117; Russell Johnson, cover, pp. 1, 42-43, 50-51, 76,
78-79, 92, 98-99, 102, 108-109, 121-122, 126, 128, 131-132, 134, 136, 143;
Terry Rishel, pp. 36-39, 46-47, 52-53, 113-114, 116, 118-119; Roger Schreiber, pp. 49, 64, 66,
68, 71, 84-86; Mike Seidl, pp. 31, 69; Kim Zumwalt, pp. 40-41

CONTENTS

EARTH, AIR, FIRE, WATER

It is a distinct pleasure for the Museum of Arts and Sciences to bring the work of one of America's greatest living artists to the Florida public. Dale Chihuly is certainly America's and perhaps the world's greatest glass artist. His meticulously crafted vessels and large free-form sculptures have brought blown and shaped glass to a preeminent position in the pantheon of international avant-garde art forms. Known for his unusual and exuberant manipulations of Venetian glass techniques wedded to the exotic and seductive qualities of the shapes and forms of ancient glass, Dale Chihuly continues to push the limits of this most beautiful and fragile of mediums into abstract and non-objective realms where color, pattern, line and volume create a new quintessential synthesis born out of earth, air, fire and water, the four classical elements of the material world.

Special thanks for bringing this significant experience to Florida must be extended to Dale Chihuly, whose frequent visits to Daytona Beach have been inspirational. Additional thanks must go to Chapman J. Root, II, for his generous support of this publication and project.

Gratitude is due to museum directors throughout the state of Florida who will host this exhibition, and sincere thanks is extended to coordinator Karen S. Chambers for making it all happen.

GARY R. LIBBY ◆ DAYTONA BEACH, FLORIDA 1993

INTRODUCTION

As a "formalist" critic, one who takes the work as it is, as an unconditional aesthetic object, I usually write about the object itself. Here I find myself writing about Chihuly as much as about his glass. I think this comes from my own recent experience as a teacher and from Chihuly's example as a classic case of modernist evolution, emphasized further by the rarity and newness of glass as a studio art material. Despite a 5,000 year history, glass has only been readily available to fine artists since the early sixties, when technical developments allowed glass to be made inventively and in adequate variety in small workshops.

Born in 1941, Dale Chihuly came of age in the early days of the new small glass studio. Although he studied interior design and initially worked as an architect, an enchantment with glass and a restless ambition drove him through the '60s; winning grants; going where he had to go to learn what he had to learn; teaming up with the right people; playing with large glass forms and installations and generally mastering the craft. In the '70s, he taught at the Rhode Island School of Design and co-founded the Pilchuck Glass School; made large pieces of blown, cast and stained glass; sometimes worked with neon, ice and other exotic materials and did architectural commissions. His energy has always rivaled his talent.

There is a popular misconception that great modernist art always makes a radical break with the past. In fact, very good new art more often breaks with the present by going back to the past (radical is from the Greek "radix" or "root"), by going back to its material essentials, as Manet did when he returned to Goya and Velasquez for the color and painterly spontaneity lacking in Salon painting. In the mid-'70s, Chihuly turned away from large multi-material pieces and began making plain, small cylindrical vessels with drawings formed from threads of hot glass picked up by rolling the semi-molten, red-hot bubble of glass over them. Somewhat later, after recovering from a serious automobile accident, Chihuly saw some Indian baskets in a museum storage room stacked sagging under their own weight, and his imagination associated these effects with glass — by nature not a substance of symmetry and applied decoration but a taffy-like liquid which "prefers" to sag and flow and swell and blend. When Chihuly saw these misshapen fiber baskets, he saw the essence of glass. More importantly, he knew what to do with it.

Thereafter, though his pieces are hardly utilitarian, Chihuly never abandoned the vessel form. He had discovered his version of the liberating narrowness that lies at the center of all good art and adopted the vessel as the formal underpinning of his art, turning his creative imagination away from glass as an ingredient or component to glass as glass. He made a series of *Pilchuck Baskets* in the summer of 1977 — pale ochre, sparsely decorated and very thin, each taking its shape and character partly from its blowing and partly from what it underwent in its making. Each crumpled, distorted and asymmetrical vessel bears the mark not only of the maker's intentions, but also the reaction of the material to the conditions of its production. This allowance was the revolution Chihuly brought to art glass, and whoever makes art glass now must take what he has done into account.

There are plenty of artists with talent and energy, but there are few who combine these with the merciless expedience which drives the great artist to make the right choices for his art no matter how they fly in the face of custom and especially when they run up against the artist's own cherished beliefs, when the ego must give in to the art and the essential qualities of the materials of the art. Chihuly has mastered glass by yielding to it, by discovering and accepting what is rather than deciding what it should be.

With the "glassness" of glass as his guiding principle and the vessel as the underlying form, Chihuly drove on with ruthless pragmatism to extract all he could out of the medium. Having long since abandoned the Romantic idea of the artist in creative isolation and borrowing the methods of the Venetians (with whom he had worked on a Fulbright scholarship in 1968), he uses a large team of highly skilled craftspeople. Unlike the Venetians, however, it is not a group replicating the master's designs in glass, but a creative team working with the master from a rough idea, improvising all the way. A Chihuly glass making session is like a movie set or a football game. The participants know what they want more or less, but they are not exactly sure how they are going to get there. Ideas spring from Chihuly, from the workers who move around him as they would around a director or a coach and from the piece itself as it takes shape. To me, it brings to mind ancient Celtic storytelling: The good whiskey and the fire and the listeners packed around the teller of tales, throwing in their two bits at every pause.

Chihuly works in series, but not always precisely sequentially. After the *Baskets* came the *Sea Forms* and the *Macchia* (Italian for "spotted"). Applied decoration disappeared early on and bright colors were willfully pressed, laid or strewn into the glass rather than on it, becoming less pictorial and more integrated. Lately, Chihuly has pushed the physical limits of glass with the large, tour de force *Niijima Floats,* made hilarious sport with Venetian glass in the rococo *Venetians* and taken nice risks with the recent, less obviously sumptuous *Pilchuck Stumps,* his first mold-blown pieces. One way or the other, he is always pushing.

Objects presented as art, as these are, in a museum, are given to us for the apprehension, appreciation, criticism, judgment and enjoyment of their physical properties and for reflection on what these properties evoke within our feelings. This may seem obvious, but it bears repeating, particularly here where the eye unaccustomed to glass as "all out" as Chihuly's can too easily be beguiled or put off by the unbridled extravagance of the pieces, especially their color, and by the easy connection our minds make to other objects in life that are bright and shiny, recklessly whimsical, garish or rudely excessive.

Like most good art objects, Chihuly's works are often liked or disliked for the wrong reasons. So take them for what they are; take them as glass. This is glass that has had things done to it no other glass has, glass made on its own terms as viscous liquid which likes to be blown out, attenuated, pressed, slumped, stretched, twisted, perforated, laden with color, fused and melted into forms that cool to brittle but stable, clear or colored, transparent or opaque solid.

As America's, perhaps the world's preeminent glass artist, Chihuly revels in the material. He pushes it to its limits and reveals its secrets. He shows us what glass feels like, so feel the glassiness. This is glass in its exultation. Enjoy it.

WALTER DARBY BANNARD ◆ UNIVERSITY OF MIAMI

DALE CHIHULY AS OF 1993

America has an art glass tradition best known through the work of one of the most admired artists of his day — Louis Comfort Tiffany. Tiffany and Frank Lloyd Wright were the first American artists whose styles and achievements had international influence, both in Europe and in the Orient.

I think it is possible to compare what Dale Chihuly is doing with what Louis Comfort Tiffany did. Tiffany ran a studio, he worked in various styles, often concurrently, and he understood the history of glass (especially the effects that time lent to the metallic surfaces of ancient glass) and was able to bring these recreated innovations into the mainstream. Chihuly, in his own way, working with a team to make one-of-a-kind pieces in series, is doing something similar.

While the techniques that Chihuly uses are not all that different from the way glass has been made historically, bonding sand, human breath and fire, there is a kind of abandon within strictures in his work, a refusal to be timid or to admit to "realistic" boundaries that makes us feel more buoyant and optimistic in its presence. You walk into a gallery with 20 *Macchias* up on white columns and you see color as you've never seen it before, as if color itself were floating in the air. It is an elevating experience. It makes you walk a bit lighter for the rest of the day.

Chihuly has brought the medium of glass to a growing new audience through his exuberance and through the constantly developing morphology of his work. These works dare to look different from year to year and yet always emanate from a consistently, even insistently personal sensibility. He's brought glass out of the crafts department and into the realm of sculpture. Chihuly's work can be appreciated as sculpture made of glass.

Chihuly's glass is purely about the creation of form, given the reality that glass is liquid when hot and that gravity is a fact of life; when liquid, glass wants to fall, to droop, to sag. Chihuly takes all that and makes it work to his own ends, leaving out all the incidentals that, I think, make much contemporary glass too cute, too "twee," as the English say.

The greatest obstacle to a universal appreciation of his work is that he's inevitably ahead of his audience. Chihuly challenges taste by not being concerned with it. He never asks himself whether his work is in good taste. I don't think he knows the difference between good and bad taste. His sole concerns are color, drawing and form. He does go over the top at times, with pieces about which people say, "This is really too much," but perhaps it's not. Five or 10 years later it's no longer too much.

In 1989 and 1990, Chihuly chiefly concerned himself with his series, the *Venetians,* inspired in the first instance by his admiration for the venerable glass tradition of Venice, since the Renaissance an acknowledged center for the high art of glass. Working with a master glass blower from Murano, Lino Tagliapietra, Chihuly pays tribute as well to his own Fulbright year in Venice. Chihuly fully integrated Tagliapietra into his longstanding team of glassworkers, his acknowledged co-heroes, and through his inventive drawings and on site direction, pro-

duced a large body of work, work which is, as I've said, "over the top" and ahead of today's taste. The *Venetians* are daring and they challenge us. I have found that over time visitors to my house lose their trepidation at the "shock" and come to find the *Venetians* an awesome delight. You don't have to convince anyone who is familiar with high art that much of Chihuly's work is beautiful. That's what I mean when I say that taste doesn't interest him. What interests him are the possibilities inherent in the material.

We often look at an artist's work and imagine that we can easily read character into it. I used to think I could. In Chihuly's case exuberance shouldn't be confused with happiness. He has his moods, and he especially seems to need to go away and come back.

He's constantly disappearing and reappearing, and I think it is then that he revitalizes himself. Chihuly looks like a pirate and sometimes acts like a pirate — perhaps it's partly a disguise, an attitude, a way of getting through life, a way of taking something negative and making it work for you.

Chihuly lost an eye in an automobile accident in England in 1976, which affected how he makes his work. With one eye he couldn't see properly as gaffer, or head of the team, where he was completely physically involved with the making of the glass. He found he could see the process better and have more control over it when he "turned over the stick" to another gaffer. He has been inspired to run a larger operation, whereas with full sight, he might have been satisfied with one or two assistants.

Chihuly works as the artist, the "onlie begetter," but he also runs the team, choosing and often training the glass blowers who work with him and some of them have worked with him for nearly 20 years. It takes eight or 10 people, with Chihuly coming in and out, watching, directing, making drawings and paintings to suggest shapes and colors and surface treatments; saying "This is good, let's move in that direction, this is the kind of color I'm looking for." Since the same team works together over a period of weeks, he can direct the team to make another piece similar in color, form or surface to another, or, alternately, he can ring in changes of color and form on a successful piece, altering it to his liking.

Chihuly's originality lies in his refusal to believe that there are fixed rules that must be adhered to. Within the confines of his craft, he sees no boundaries. He is able with each new series to invent work that is conceived in formal terms with all the strictness of an aesthetic that deals uniquely with form, color and surface: yet, at the same time, each series relates back to the real world, the world of nature and civilization, the world of the sea on the one hand and the glass of Venice on the other. In the *Persians,* the ancient Middle East is invoked and evoked, while Chihuly's *Baskets* owe a clear debt to the woven baskets of the Native Americans of the Northwest.

I recently saw Chihuly's one-man show at the new Seattle Art Museum. Curated by Patterson Sims, it was well thought out and planned, and it left one with a sense of his achievements to date. But there was one aspect of the show that I think was particularly original. Most large museum shows reassemble work that is out in the world, in private collections, galleries and museums. It is a difficult task, indeed, to convince all these individuals to lend work they cherish for long periods to unfamiliar venues.

Chihuly sees it differently. He doesn't want to rest on his laurels and review the past. And, as there is no such thing as a previous style for him — everything he has done remaining fresh in his armory — he re-makes the work and lends the exhibition himself to the institution. He and his team re-conceive the work, one series or another, and, I have noticed, almost invariably the works grow larger and more colorful in repetition. There is something touching about seeing old *Macchia* and new together. There is a classical dignity and modesty to the earlier versions that give way to greater confidence and pyrotechnical virtuosity, a kind of baroque exoticism, in the later examples. Indeed, I think we may have discovered an art historical law: work in revival always grows larger the next time. Think of the ancient world and the Renaissance, or more humbly, the way the decorative artists of the 1950s enlarged the forms and details of the Art Deco they were so often inspired by.

Of course, glass can only be stretched so far without breaking. There are controls inherent in the medium. The *Niijima Floats* of 1991 and 1992 are probably as large and as heavy as glass will allow. That doesn't mean that some technique or technology will never come along to refute this, but at this point I can't imagine it. Glass is so very much handmade. That's one aspect of it that we instinctively relate to.

Chihuly's work is American in its apparent vulgarity, its brazenness and its fearlessness to move farther out west even if there is no further west to move to. There's a kind of pioneering spirit to it. And yet, the Musée des Arts Décoratifs, Palais du Louvre, in Paris gave Chihuly a very rare one-man show. The exhibition was deemed superb. On an aesthetic level, this work succeeds in Paris as in America, crossing national boundaries as it transcends those artificial barriers between art and craft.

HENRY GELDZAHLER

BASKETS

With the *Baskets* Chihuly liberated the glass blowing process from the restrictions of symmetry, allowing glass to do what it wanted to do naturally, respond to gravity. These pure forms in sheer shades, originally tabac or the red of embers and later honeyed yellows and the blues of dusk, translated woven fiber into a less flexible but more mercurial material — glass. The *Baskets* enabled Chihuly to combine his early interest in weaving with his passion for glass blowing. — *Karen S. Chambers, 1992*

Dale Chihuly is representative of the artist who chooses to confront the demanding, paradoxical medium with his own vitality, passion, intellect and skill. Acting and reacting, acting and reacting, he is in daily pursuit of the essence of his medium, attempting not only to probe and question the definitions and standards of the past, but to open himself to the improvisational possibilities of glass. . . . His *Basket* series is an exploration of form rather than surface. It was inspired by examples of Indian baskets from the Northwest Coast. . . . Many of these artifacts, he observed with fascination, seemed to be collapsing under their own weight. This tension, pressure or force is reflected in his glass baskets, which appear malleable and very light . . . They seem to be moving under a stress more sensed than seen. — *Michael W. Monroe, "Baskets and Cylinders: Recent Glass by Dale Chihuly," Renwick Gallery, National Collection of Fine Arts, 1978*

The *Baskets* turned out to be one of the best ideas I have ever had. I had seen some beautiful Indian baskets at the Washington State Historical Society and I was struck by the grace of their slumped, sagging forms. I wanted to capture this grace in glass. The breakthrough for me was recognizing that heat was the tool to be used with gravity to make these forms. — *Dale Chihuly, 1992*

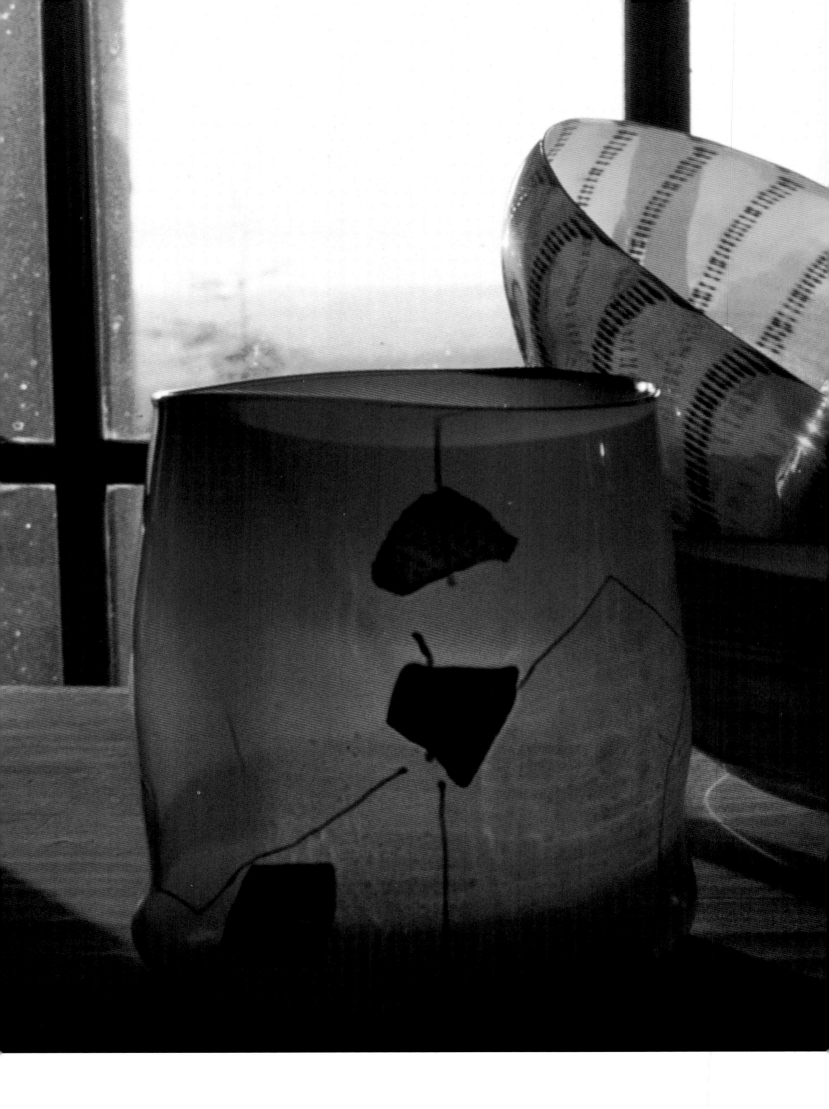

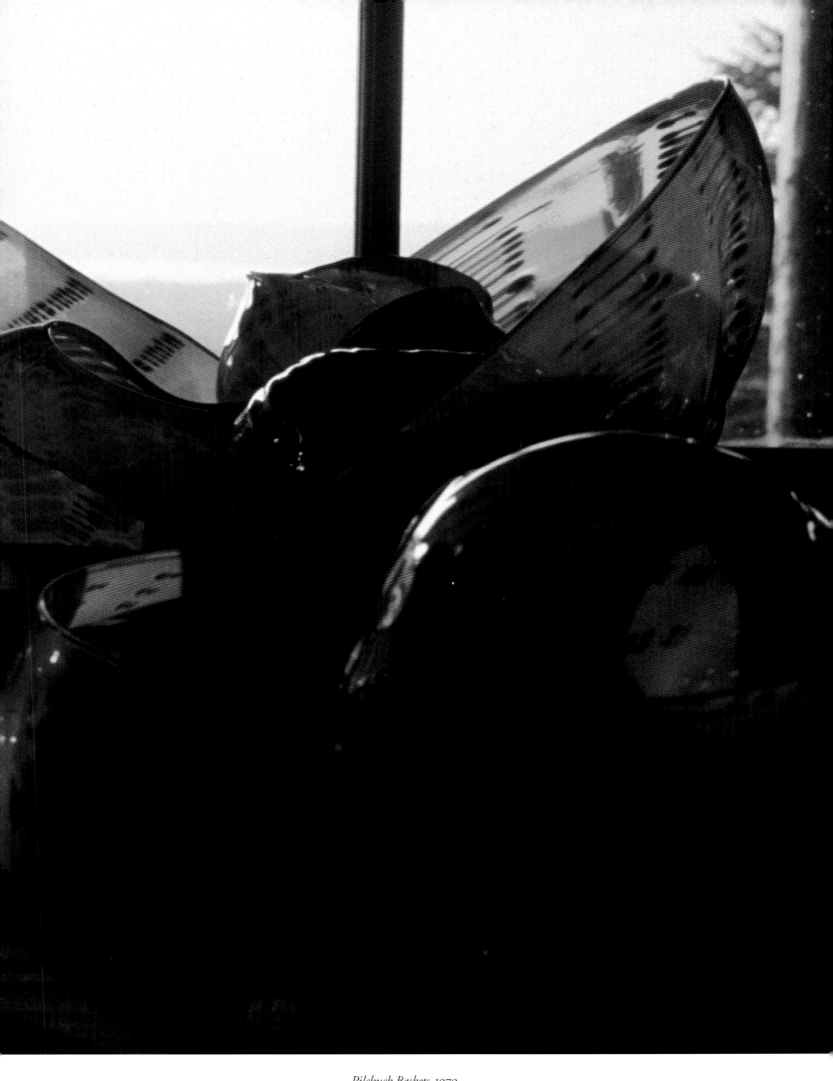

Pilchuck Baskets, 1979

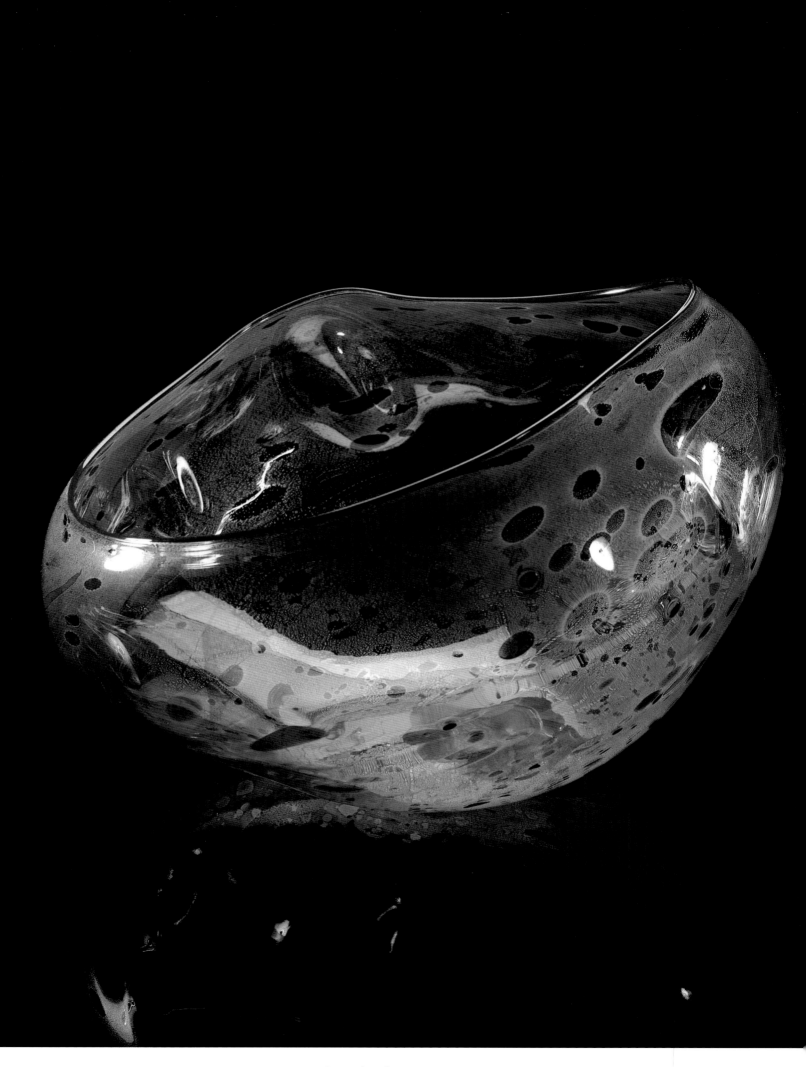

Lime Green Basket With Red Lip Wrap, 1992, 9 x 14 x 13 inches

Basket Drawing, 1988, 30 x 22 inches, Graphite, colored pencil and watercolor on paper

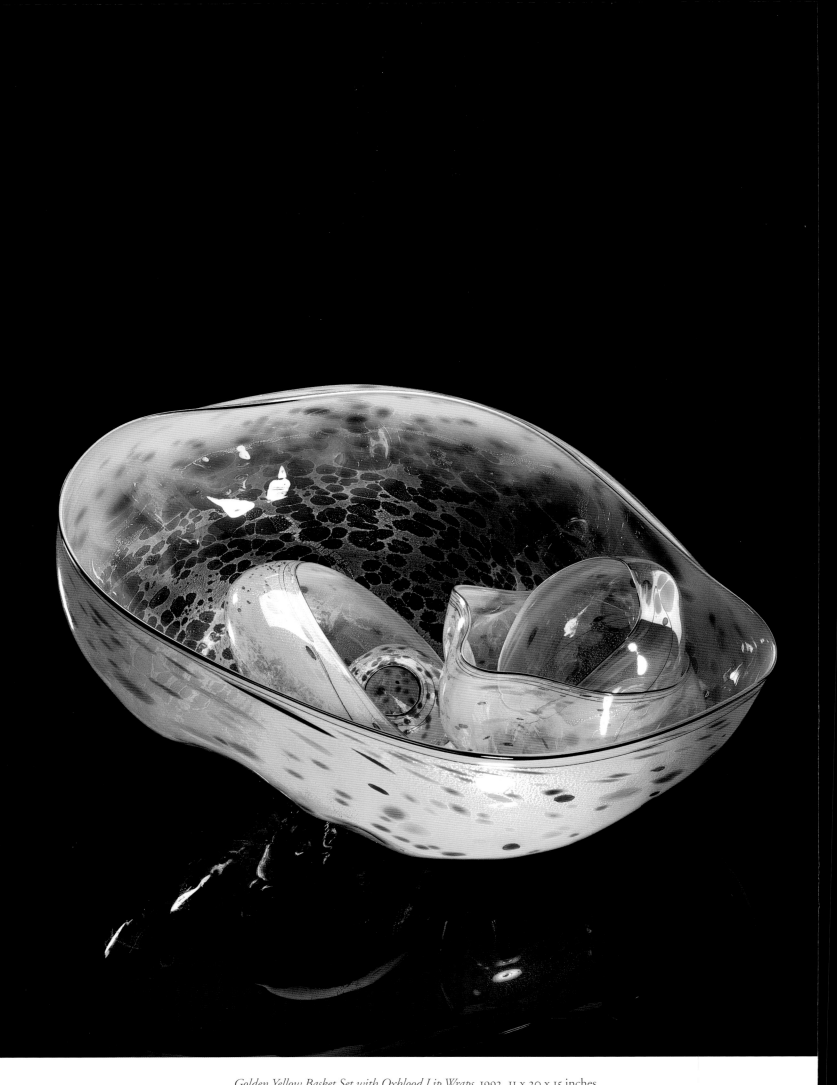

Golden Yellow Basket Set with Oxblood Lip Wraps, 1992, 11 x 20 x 15 inches

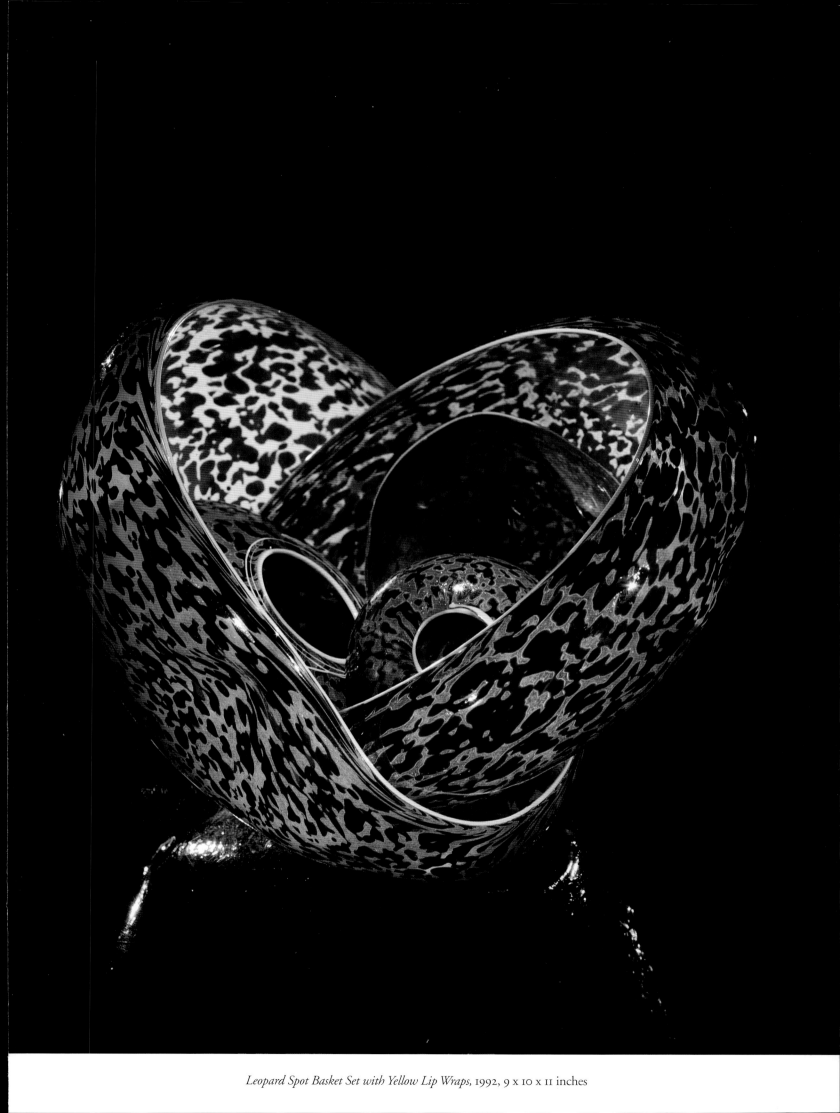

Leopard Spot Basket Set with Yellow Lip Wraps, 1992, 9 x 10 x 11 inches

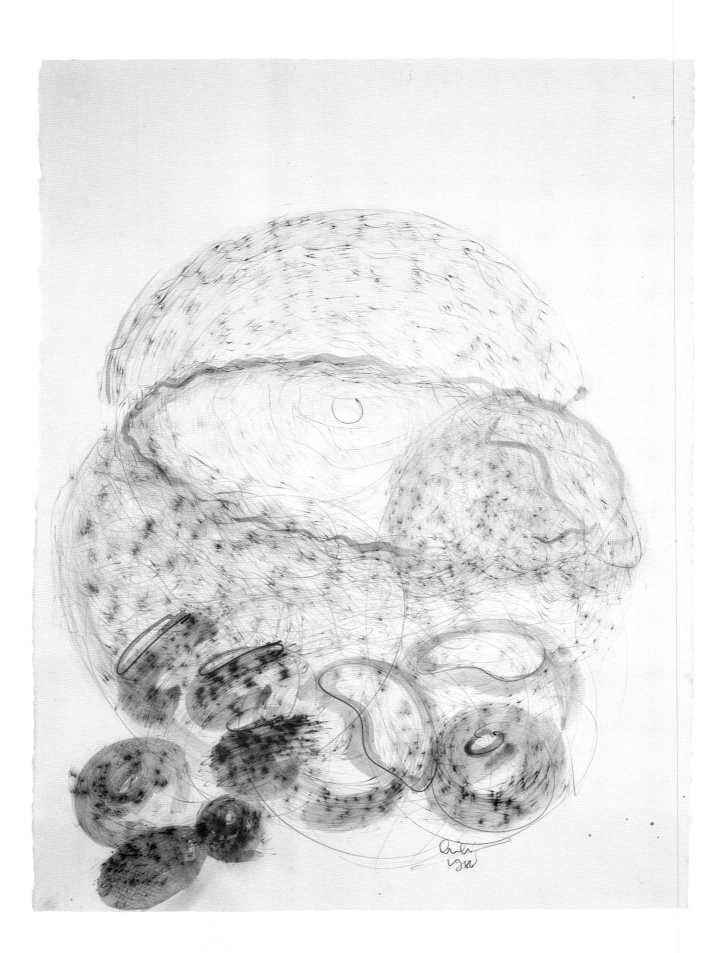

Basket Drawing, 1986, 30 x 22 inches, Graphite, colored pencil and watercolor on paper

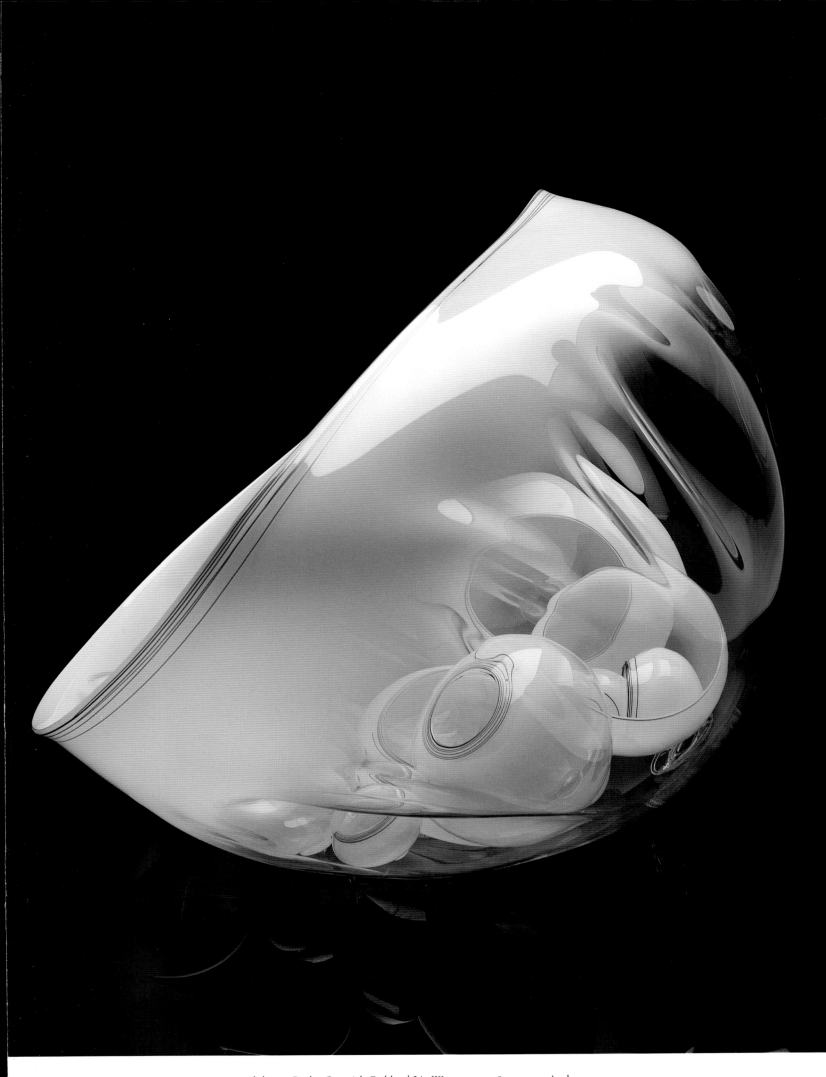

Alabaster Basket Set with Oxblood Lip Wraps, 1991, 18 x 27 x 21 inches

SEA FORMS

When thin glass threads are trailed over the ridges in a continuous motion, they adapt to the unique contours of each form so that a fusion of form and decoration occurs, differing markedly from the applied patches of drawing on many of the earlier *Baskets*. . . . The new forms resemble sea urchins, distended sacks with small openings covered in pinpoints of white that spiral out from their opening. Other forms are more elegantly abstract. — *Linda Norden, Arts Magazine, 1981*

Chihuly's best pieces imply pure movement. It's as if his forms will surface to the top of the gallery room as soon as night comes. The pieces seem to float, one inside another, delicately tangential, each existing on its own.
— *Susan Zwinger, Santa Fe Reporter, 1981*

The *Sea Forms* seemed to come about by accident, as much of my work does — by chance. We were experimenting with some ribbed molds when I was doing the *Basket* series. By blowing the pieces into ribbed molds, it gave them more strength. It's sort of like corrugated cardboard — or actually, like sea shells themselves, which are very often ribbed. Then the *Baskets* started looking like sea forms, so I changed the name of the series to *Sea Forms,* which suited me just fine in that I love to walk along the beach and go to the ocean. And glass itself, of course, is so much like water. If you let it go on its own, it almost ends up looking like something that came from the sea. — *Dale Chihuly, 1992*

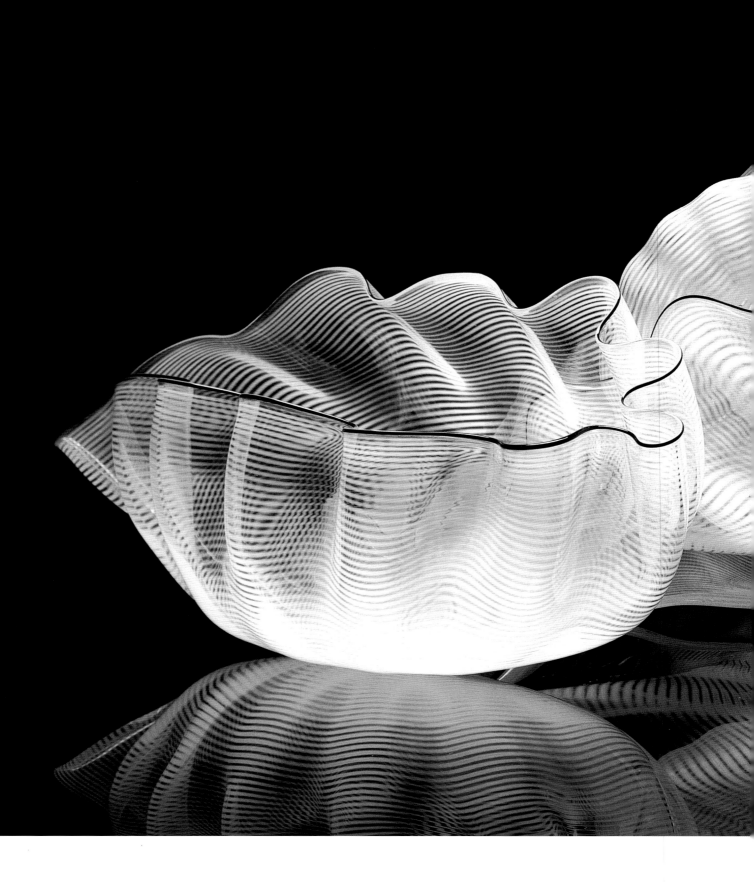

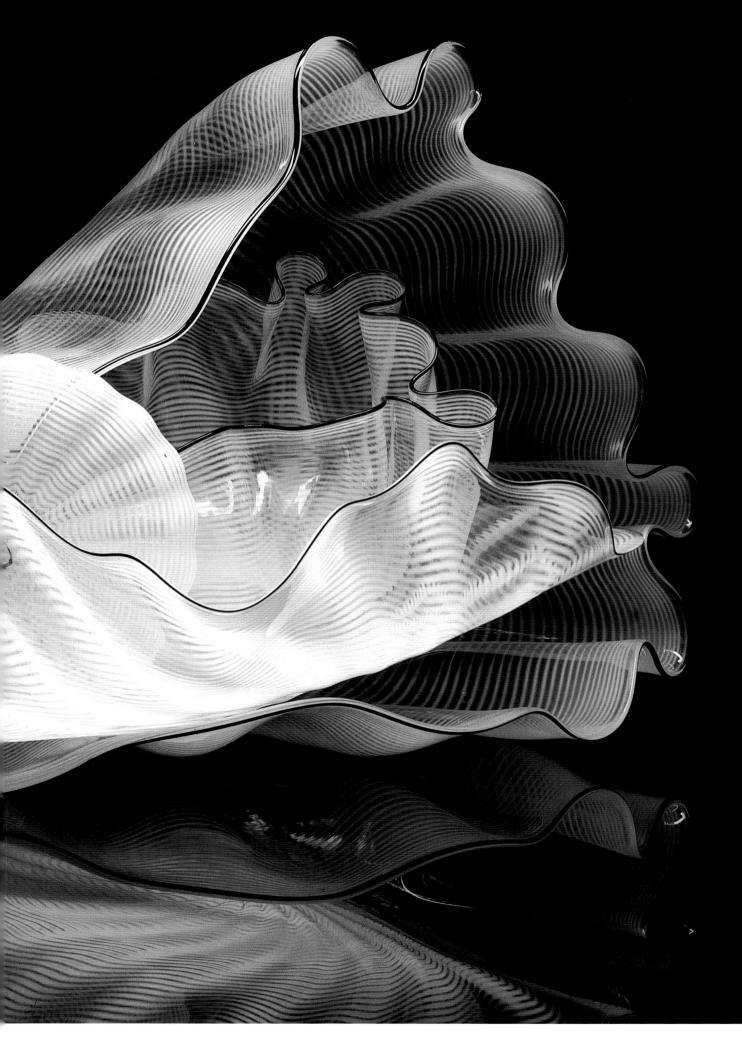

White Sea Form Set with Black Lip Wraps, 1984, 16 x 28 x 20 inches

Sea Form Drawing, 1988, 30 x 22 inches, Acrylic and graphite on paper

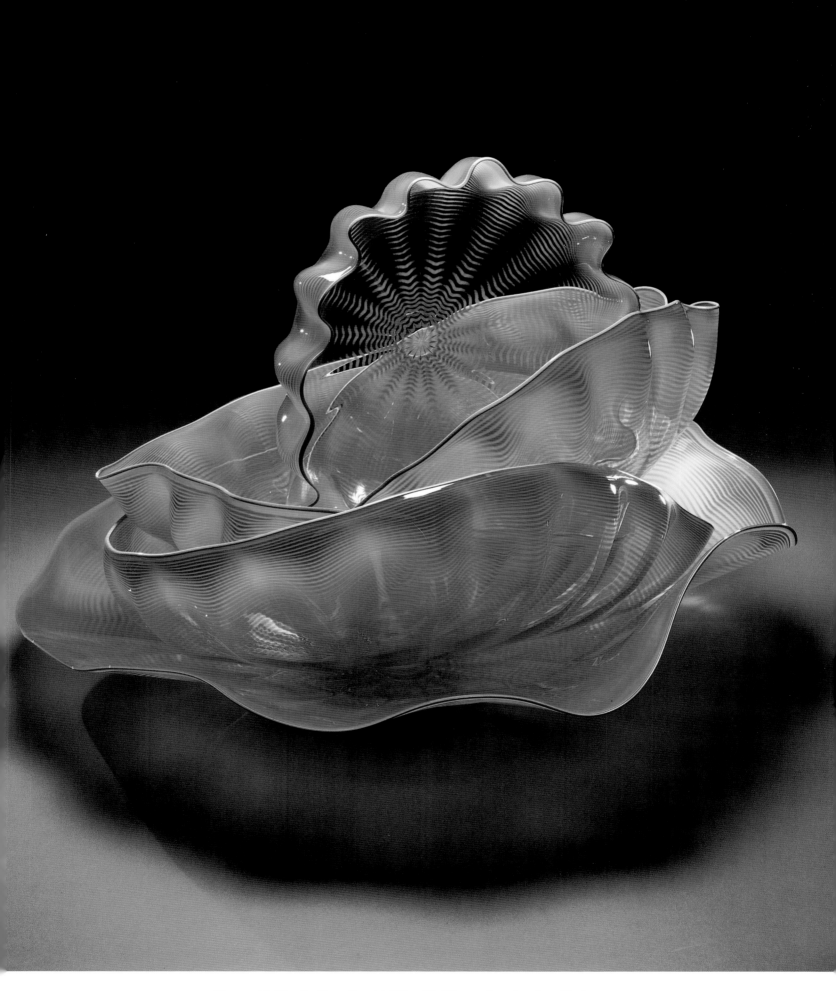

Honeysuckle Blue Sea Form Set with Yellow Lip Wraps, 1989, 26 x 36 x 36 inches

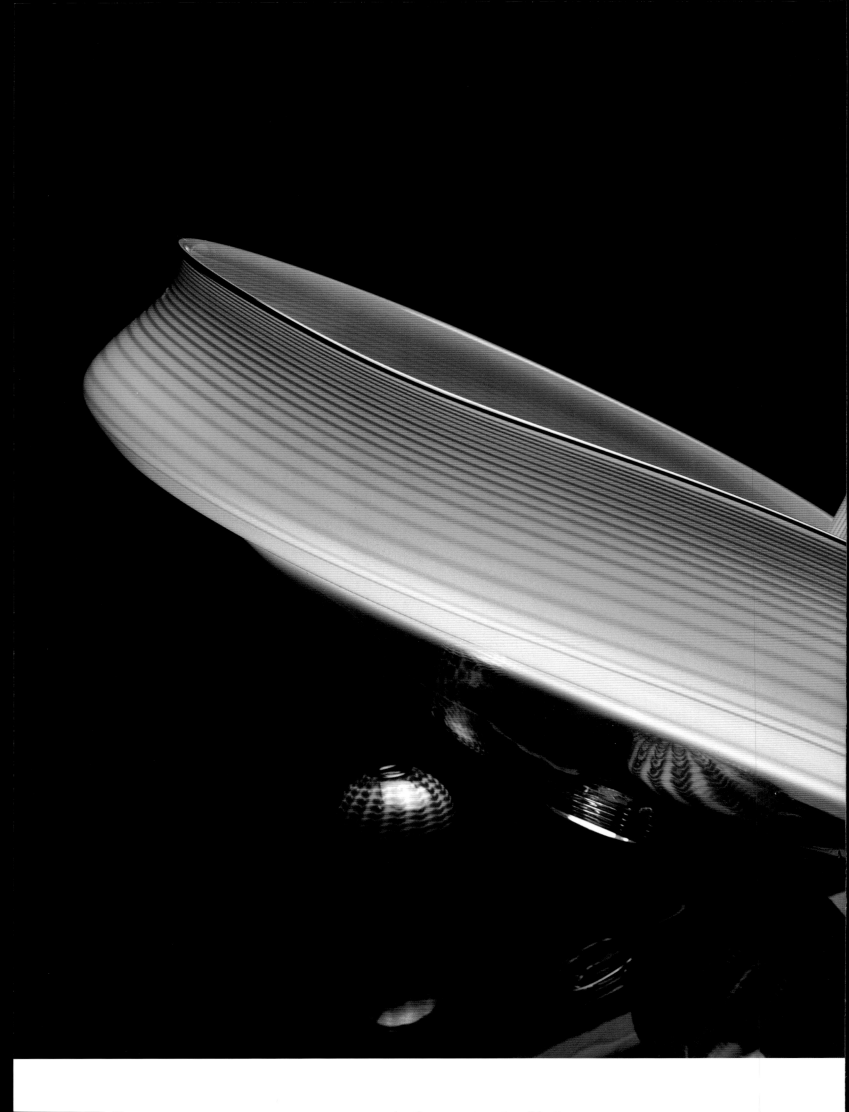

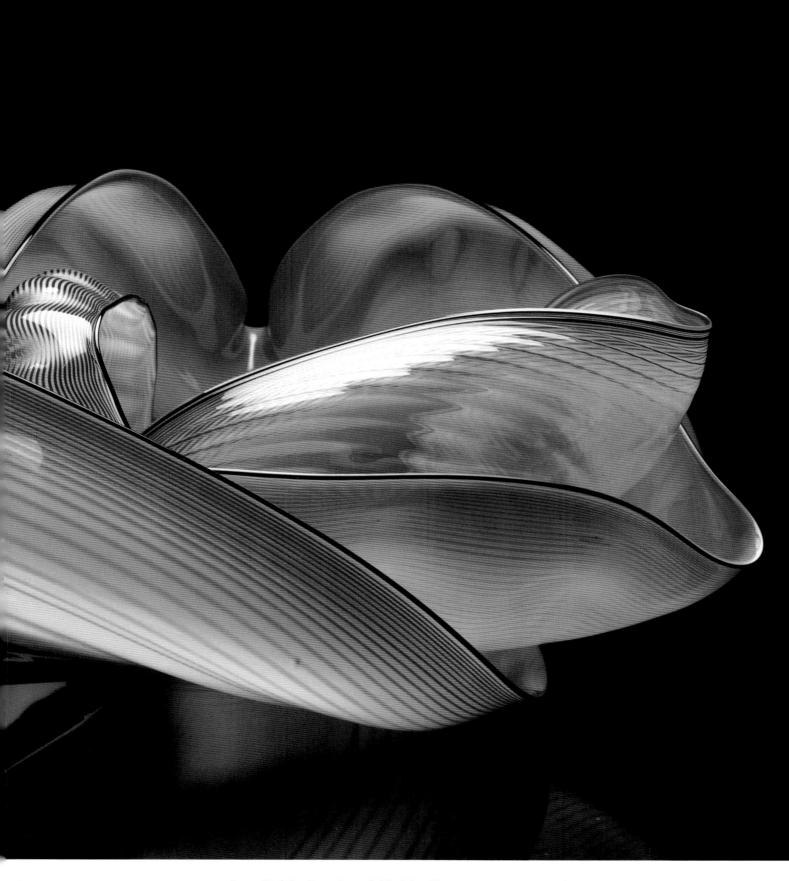

Ocean Pink Sea Form Set with Black Lip Wraps, 1985, 16 x 38 x 34 inches

MACCHIA

I was always looking at all these 300 different color rods that make up our palette.
They come from Europe, mostly from Germany. I think it was in 1981 that I
woke up one morning and said, "I'm going to use all 300 colors in as many possible
variations and combinations as I can." I began making a series of pieces with
one color inside and another color outside, and I discovered a way to put opaque
white "clouds" between the two layers to clarify the colors, to keep the
colors separate. — *Dale Chihuly, 1992*

When glass objects reach the scale of Chihuly's *Macchia* series, a new identity is
achieved. Glass no longer has to pretend to be unassuming, undemanding and fragile,
even though it continues to play on ephemerality. In the *Macchia,* the strength
of the glass is suggested with references to geological formations. The colors in the
Macchia are related to the colors of stones. Seen under bright light they look like nature
caught on fire, nature in molten flux, nature in the process of being created.
— *Robert Hobbs, "Chihuly's Macchia," Dale Chihuly: objets de verre, Musée des Arts
Décoratifs, Palais du Louvre, 1986*

I had to come up with a name for the series and I called my friend Italo Scanga and said,
"Italo, what's the word for 'spotted' in Italian?" And he said, "'Spotted' in Italian
is *macchia,* and *macchia* comes from immaculate, meaning 'unspotted'." It also means
"patina" and "to sketch" and there are artistic roots to it as well. I really like all
of the meanings. — *Dale Chihuly, 1992*

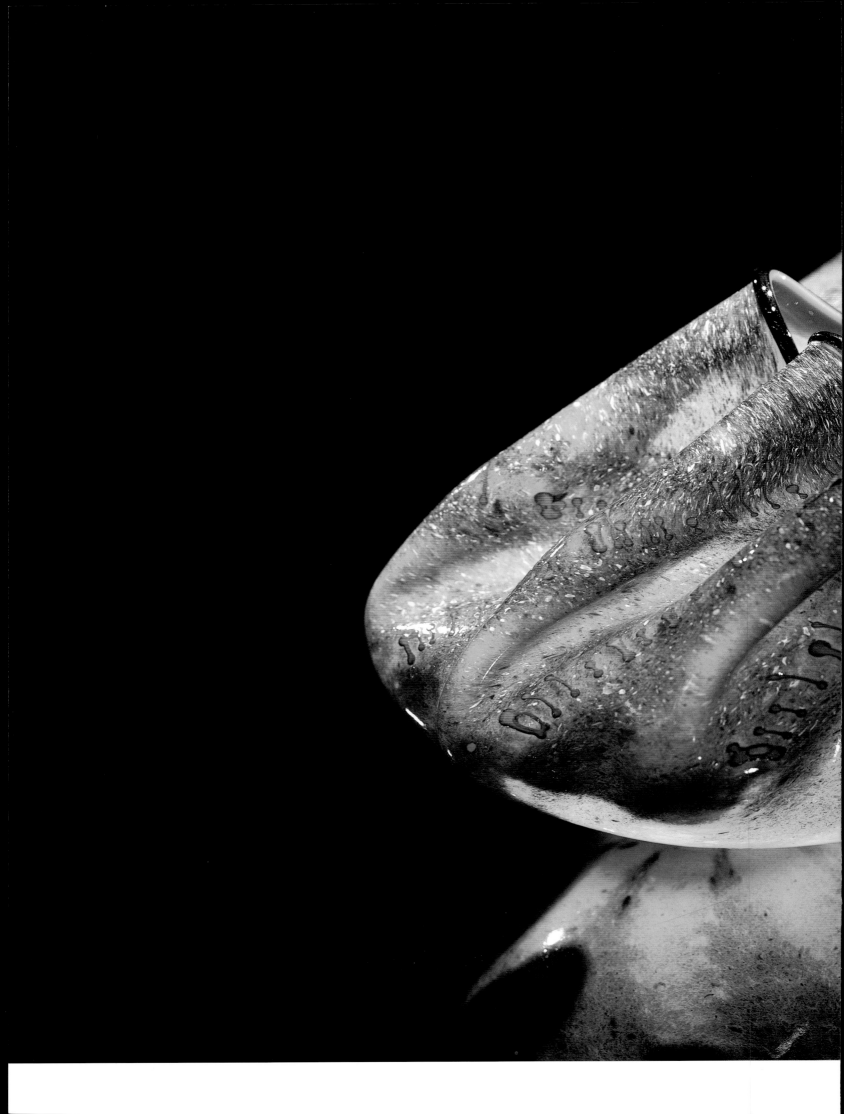

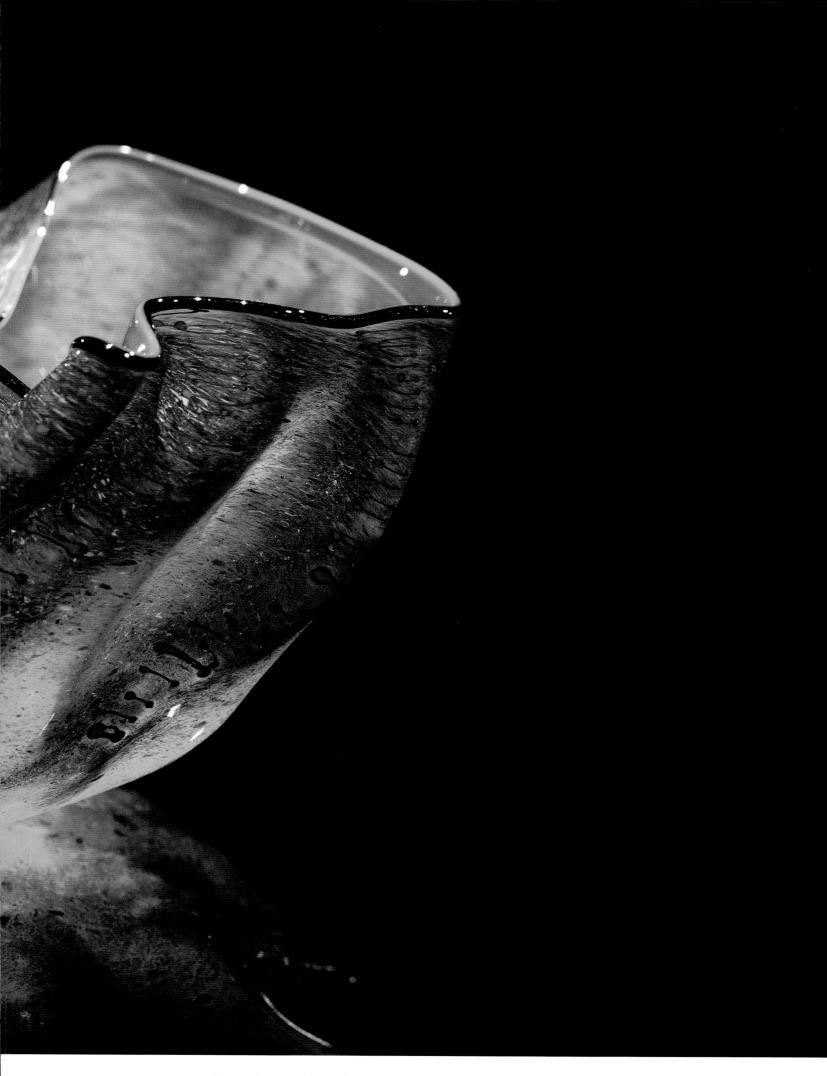

Swamp Green Macchia with Sky and Navy Blue Lip Wrap, 1981, 5 x 8 x 6 inches

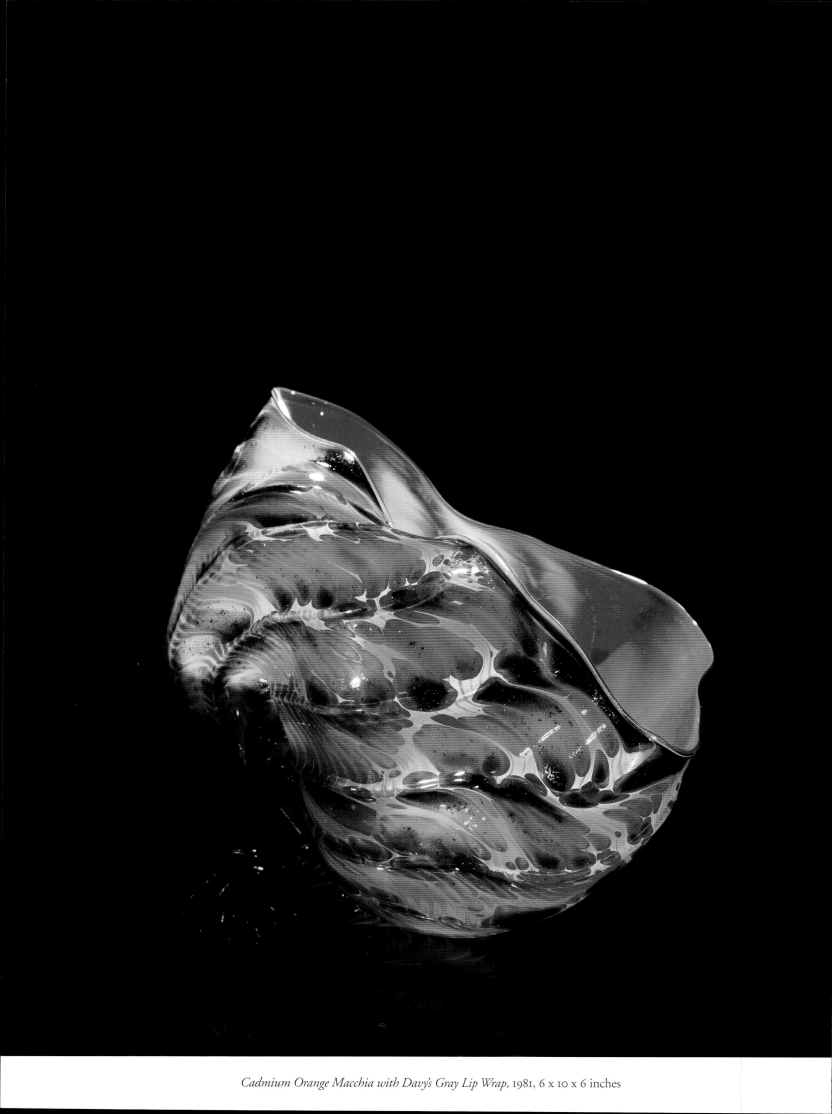

Cadmium Orange Macchia with Davy's Gray Lip Wrap, 1981, 6 x 10 x 6 inches

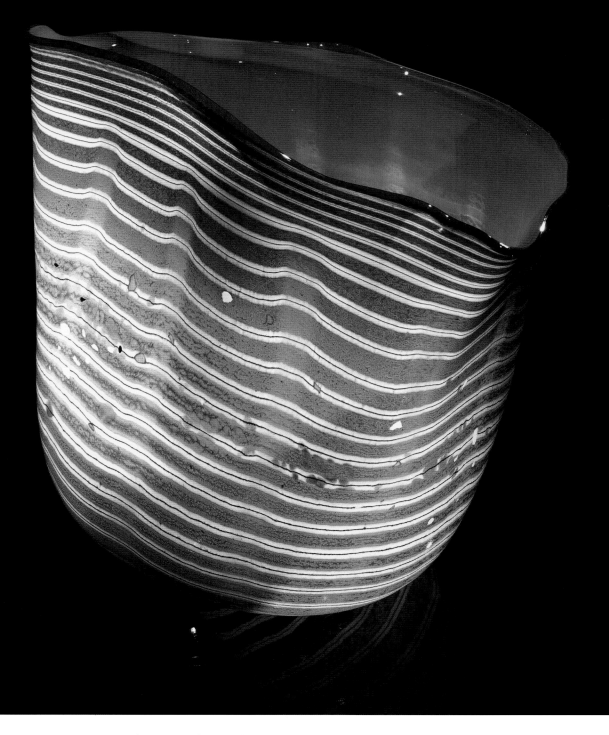

Ultramarine Blue Macchia with Red Lip Wrap, 1983, 15 x 16 x 11 inches

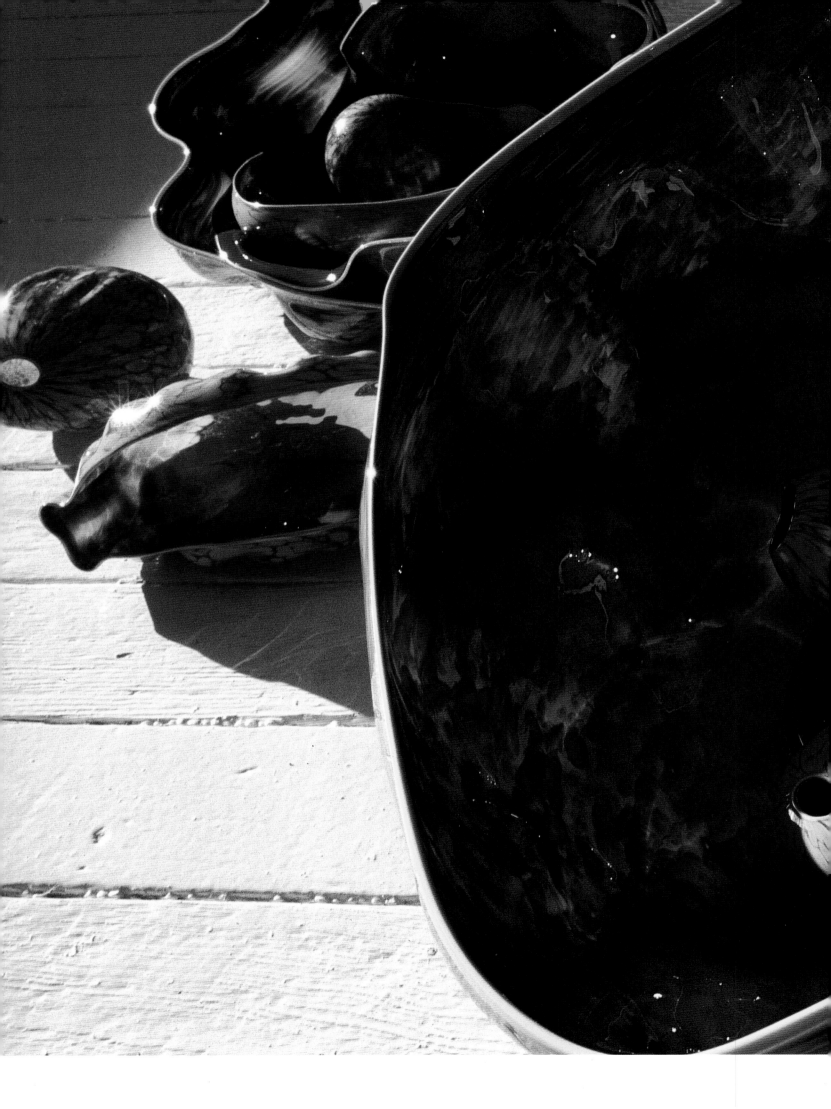

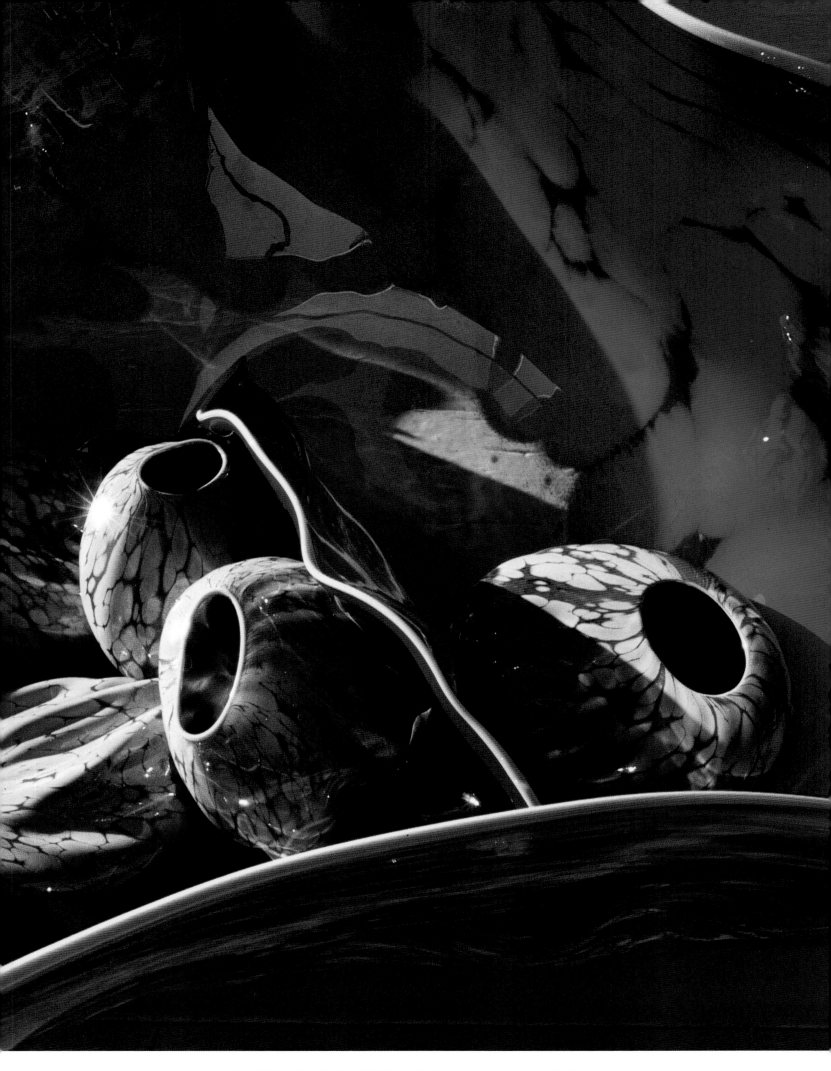

Cobalt Blue Macchia Set with Yellow Lip Wraps, 1986, 16 x 44 x 39 inches

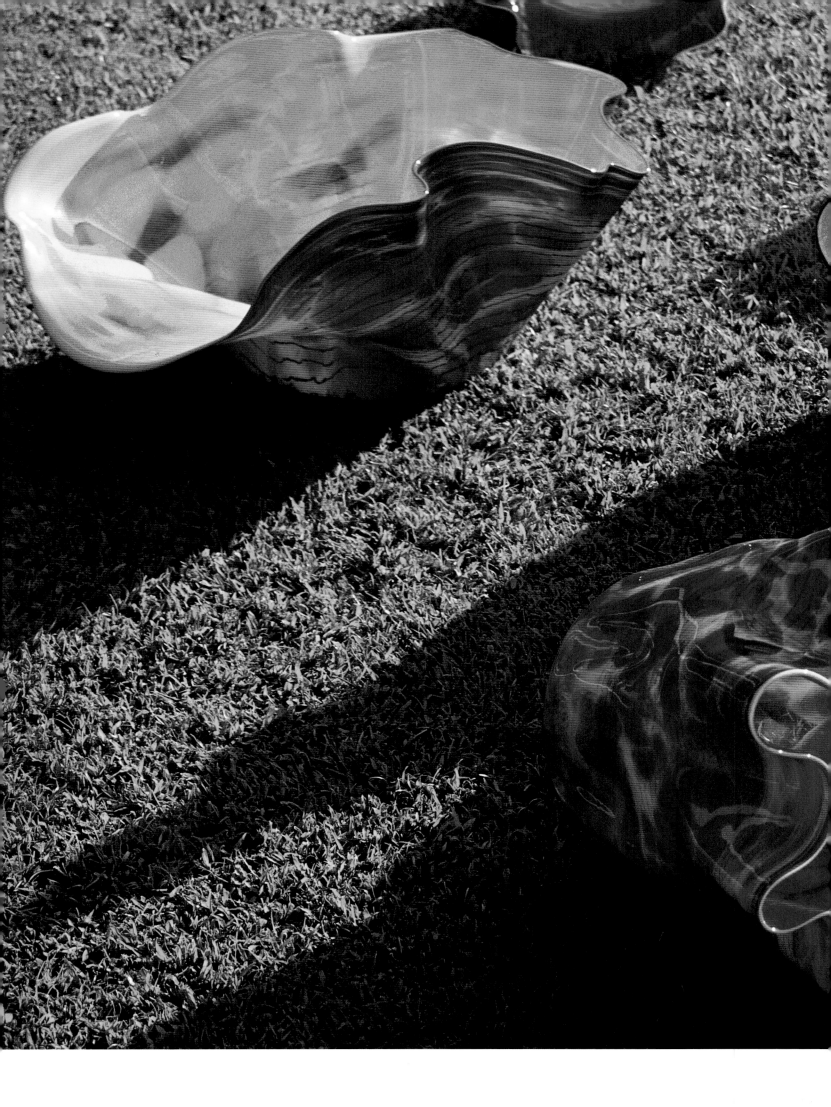

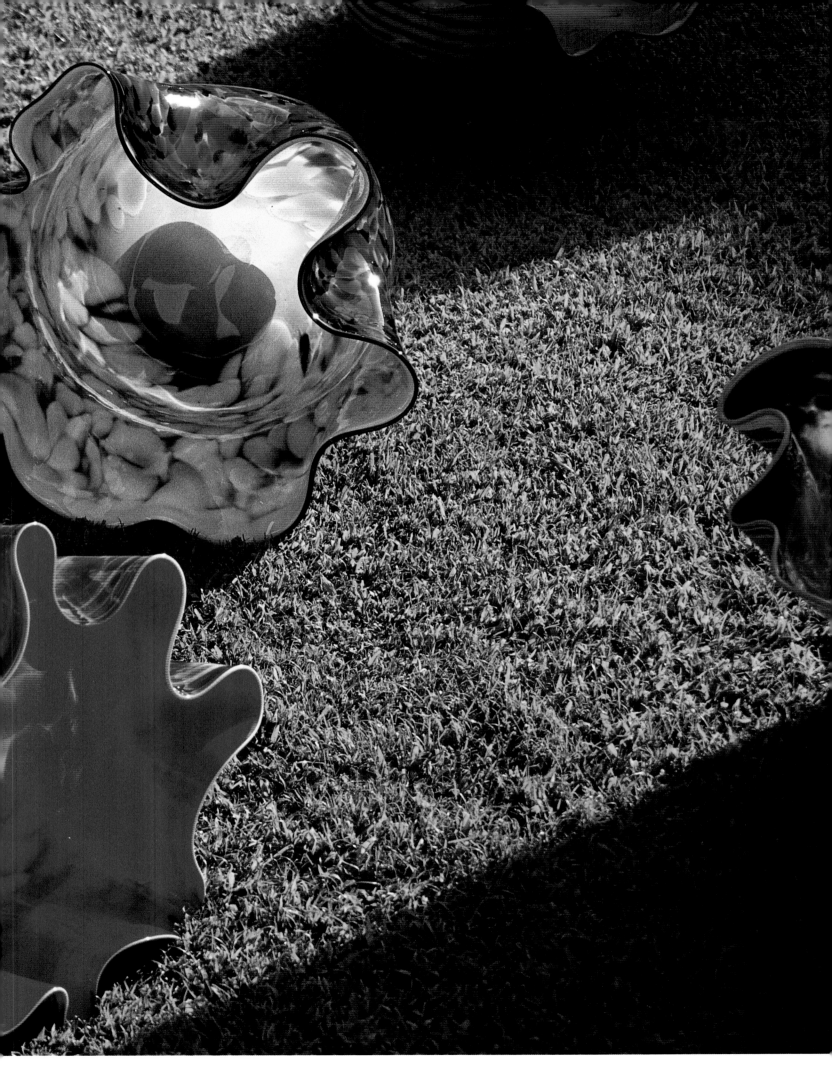

Macchia Courtyard, "Chihuly Courtyards," Honolulu Academy of Arts, 1992

PERSIANS

The *Persians* started out as a search for forms. I had hired Martin Blank in 1985, just out
of R.I.S.D., and I saw right away that he was very talented and creative. He wasn't
concerned as much with craftsmanship as he was with experimenting, so I immediately
set him and Robbie Miller up in a corner of the hot shop at Pilchuck while the big team,
headed by Billy Morris, was working on large *Macchia*. I would make large pencil
drawings for Martin and Robbie with a couple dozen small forms and then I would put
an *X* under the ones I wanted them to go for. Over the next year, we made more
than 1,000 miniature experimental forms. — *Dale Chihuly, 1992*

The individual elements in the *Persians* still exude life. The elasticity of each form
manifests glass's real character as a frozen liquid, as molecules held in suspension. . . .
The individual elements composing the *Persians* simulate the rhythms and forces of life. . . .
The delicacy and fragility of Chihuly's glass as well as its tentative placement is
an impression of this world: The series is like some wonderful perfume blown across the
great central Iranian desert. The pieces allude to romance, mystery, an ancient world
and its survival in the present. . . . Existence, as the *Persians* suggest, is always tentative and
precarious, always something to be fought and won. — *Robert Hobbs, "Dale Chihuly's
Persians: Acts of Survival," Chihuly/Persians, Dia Art Foundation, 1988*

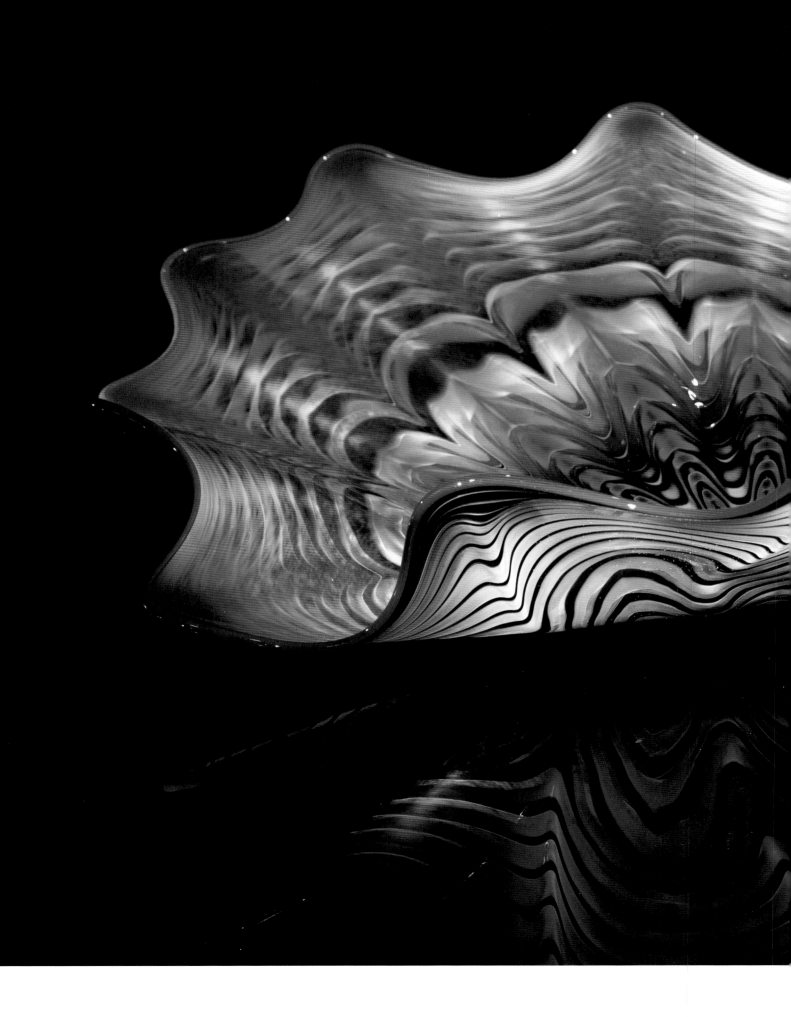

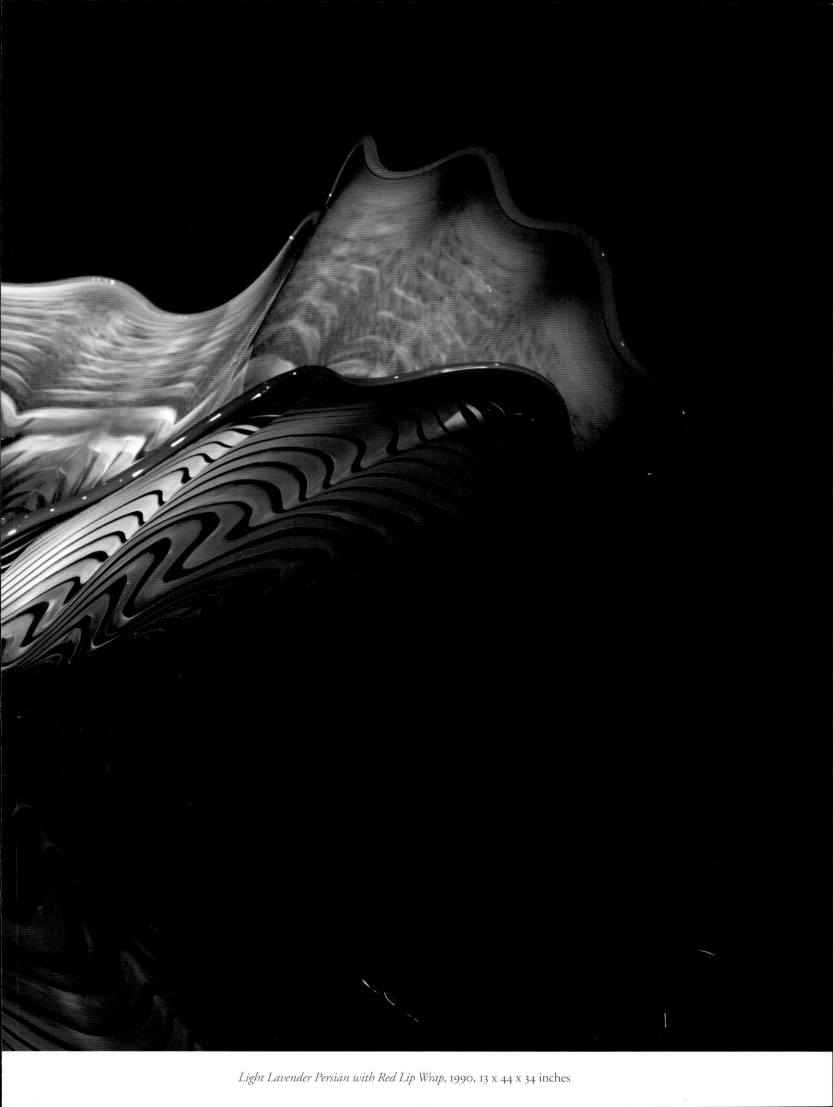

Light Lavender Persian with Red Lip Wrap, 1990, 13 x 44 x 34 inches

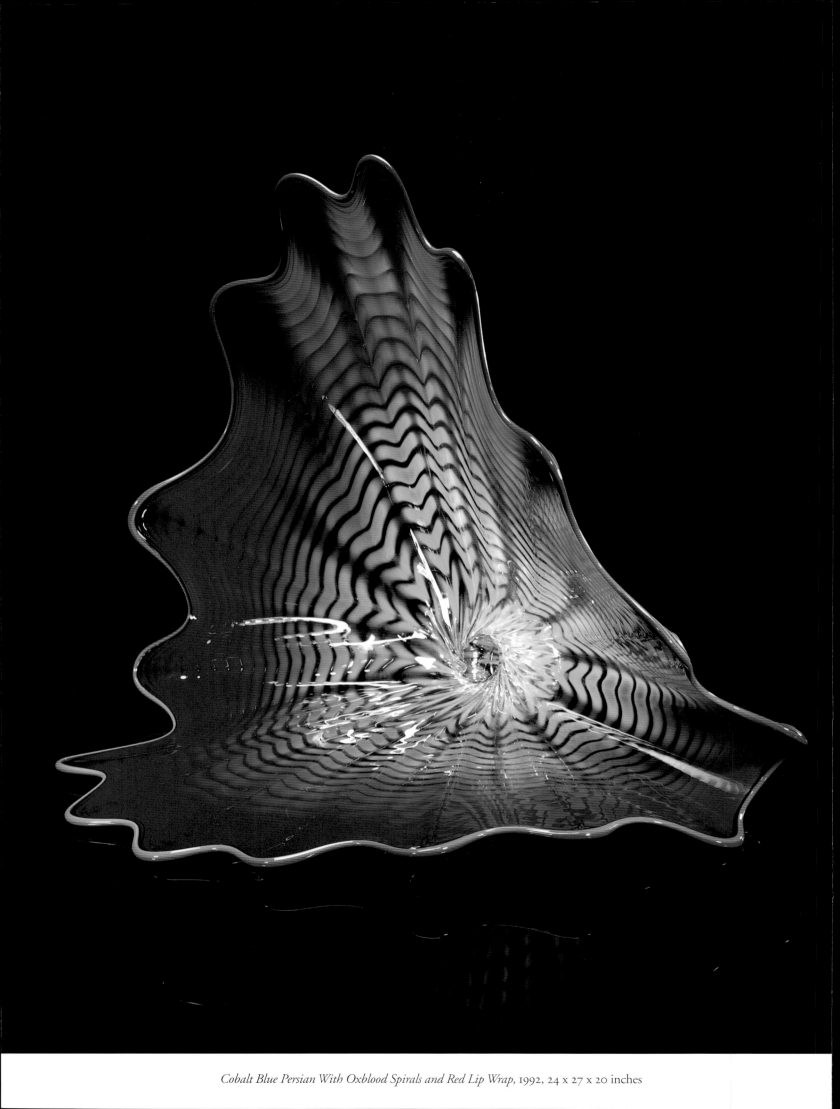

Cobalt Blue Persian With Oxblood Spirals and Red Lip Wrap, 1992, 24 x 27 x 20 inches

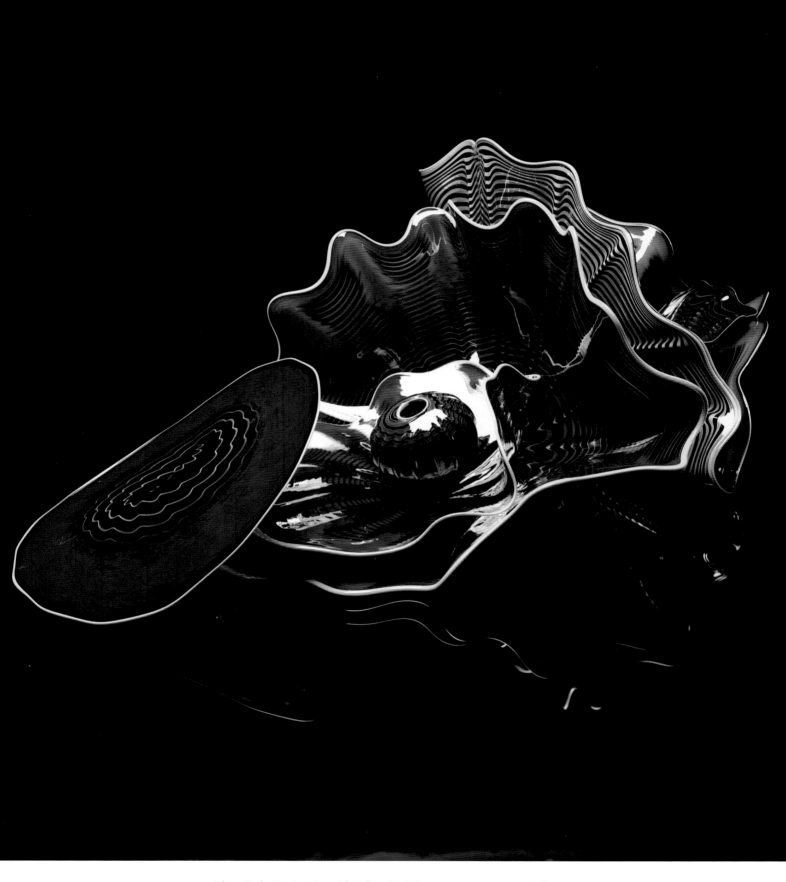

Plum Violet Persian Set with Yellow Lip Wraps, 1990, 12 x 36 x 23 inches

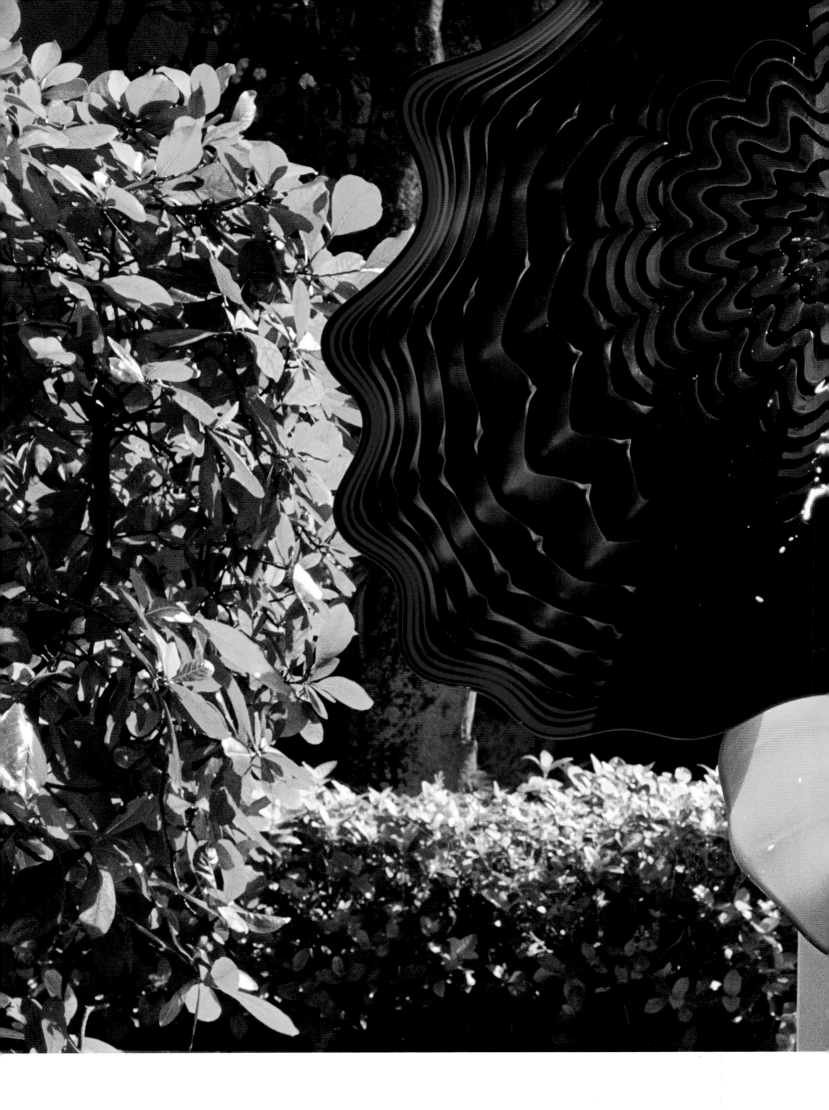

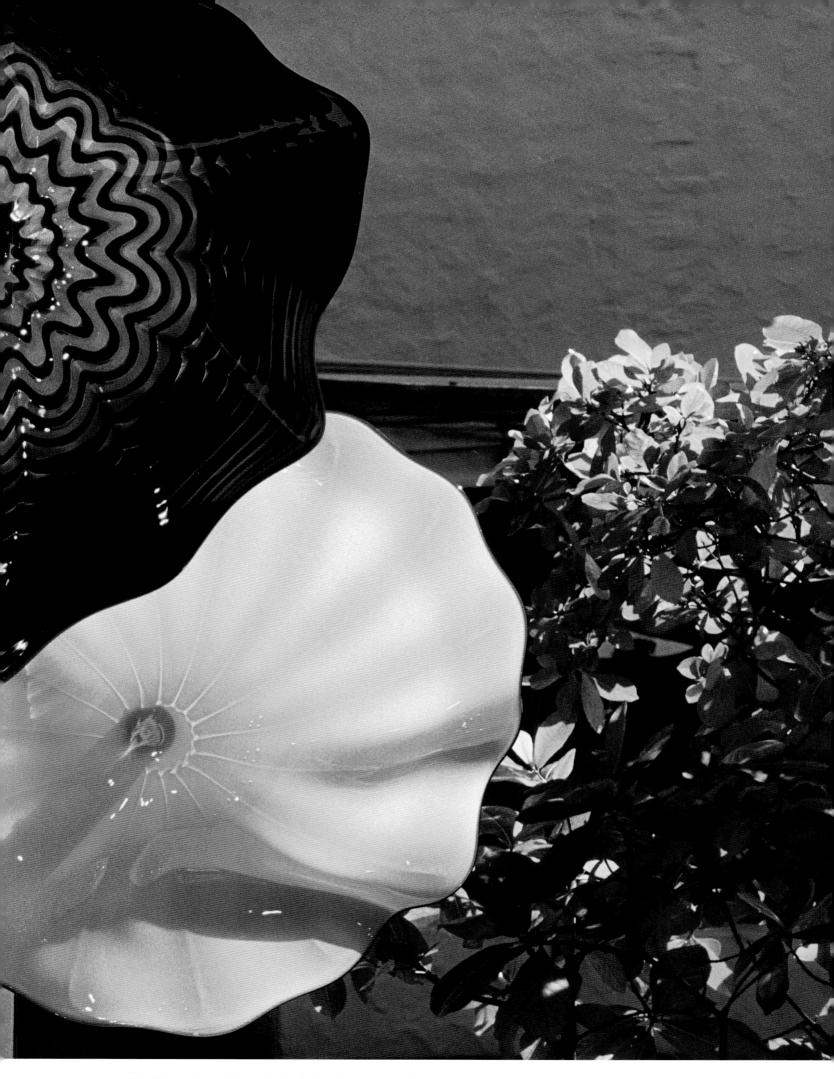

Honolulu Academy of Arts Window, "Chihuly Courtyards," Honolulu Academy of Arts, 1992, 75 x 60 x 20 inches

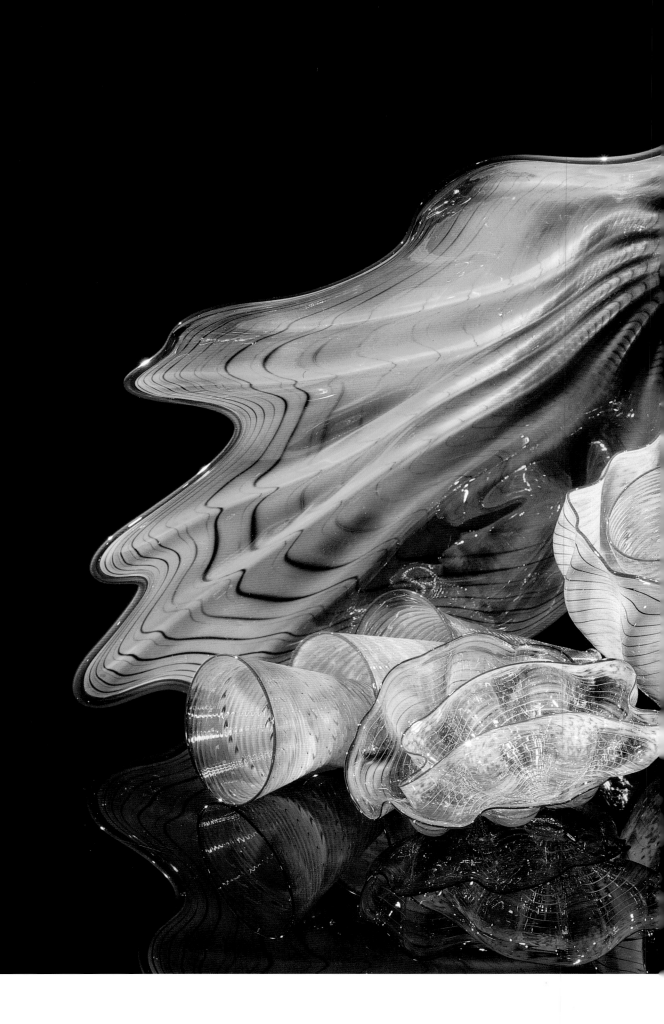

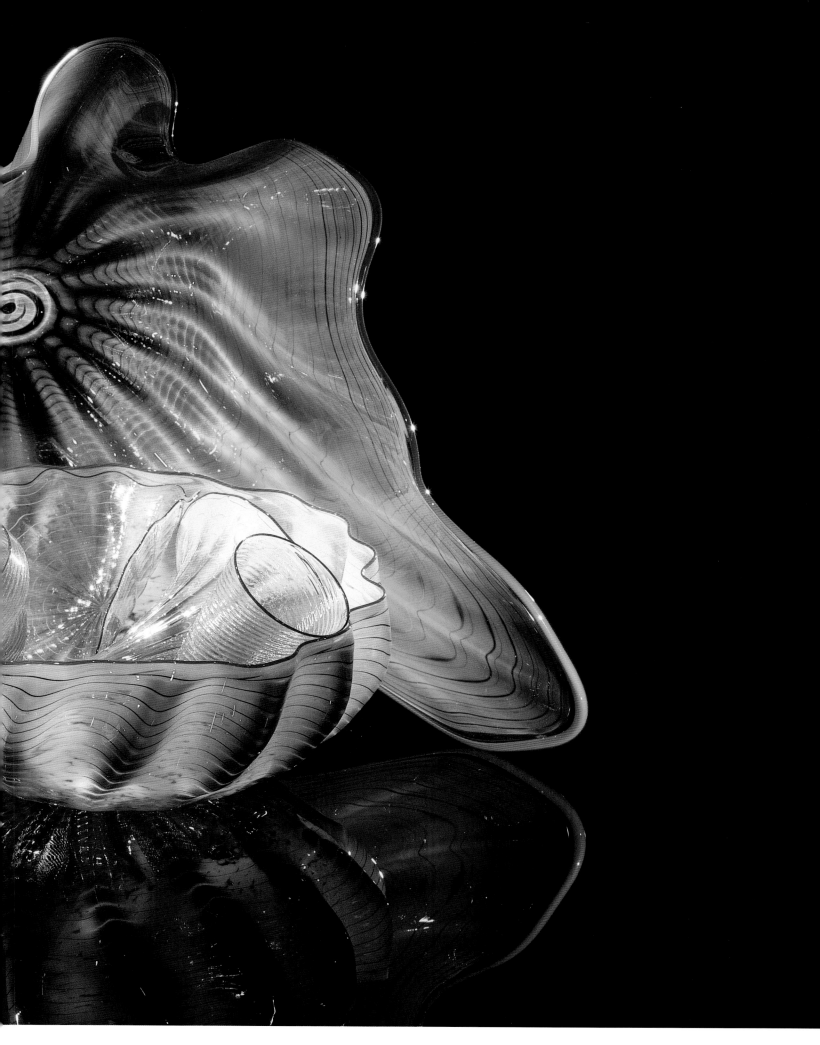

Leaf Green Persian Set with Orange Lip Wraps, 1992, 21 x 23 x 22 inches

SOFT CYLINDERS

Although the woven image continues to act as a source of inspiration, we are not
as conscious of the specific design origin. The warp and weft threads explode
with an unprecedented emotional vitality. . . . Glass threads are assertively thrust helter-
skelter. Boldly colored lip wraps on the cylinder's top edge become necessary to cap this
energy from expanding vertically, while the warp and weft threads grasp the entire
cylinder, totally integrating the surface calligraphy with the ground. . . . There is
no surface decoration here. The larger linear imagery has penetrated the glass, creating
an animated interior layer that complements and intensifies the expressive mood
of these pieces. — *Michael W. Monroe, "Drawing in the Third Dimension," Chihuly:
Color, Glass and Form, Kodansha International Ltd., 1986*

The essence of the *Soft Cylinders* is really at the point of the "pick up." First, a very detailed
glass drawing — we call it a shard — is prepared before the blowing starts, usually
by Flora Mace. Then the glass shard is carefully placed on a hot plate with hundreds of
glass threads all around the drawing. About halfway into the blowing process,
right after the last gather of glass has been dipped from the furnace, the gaffer, who was
originally me, then Bill Morris, and now it's usually Rich Royal, comes down on
it with the molten glass and it fuses to the surface. This is the most exciting moment
of making a *Soft Cylinder.* The shard may crack at this point and the glass threads
go flying everywhere. — *Dale Chihuly, 1992*

Soft Cylinder Drawing, 1992 45 x 30 inches, Acrylic on paper

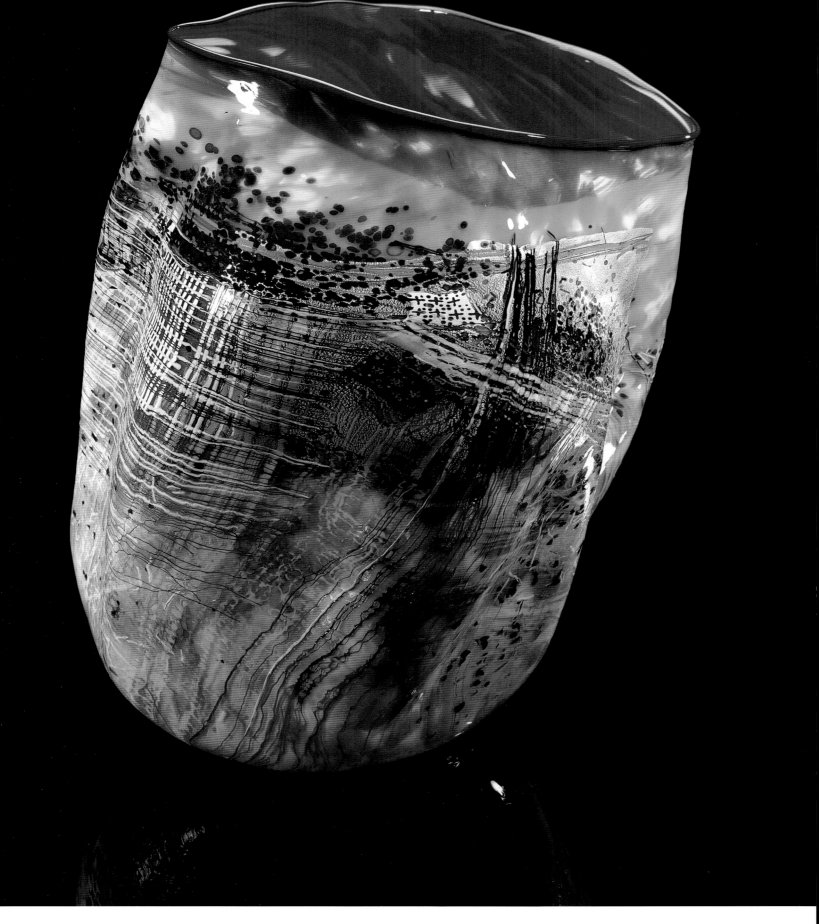

Prussian Red Soft Cylinder with Blue Lip Wrap, 1992, 19 x 16 x 15 inches

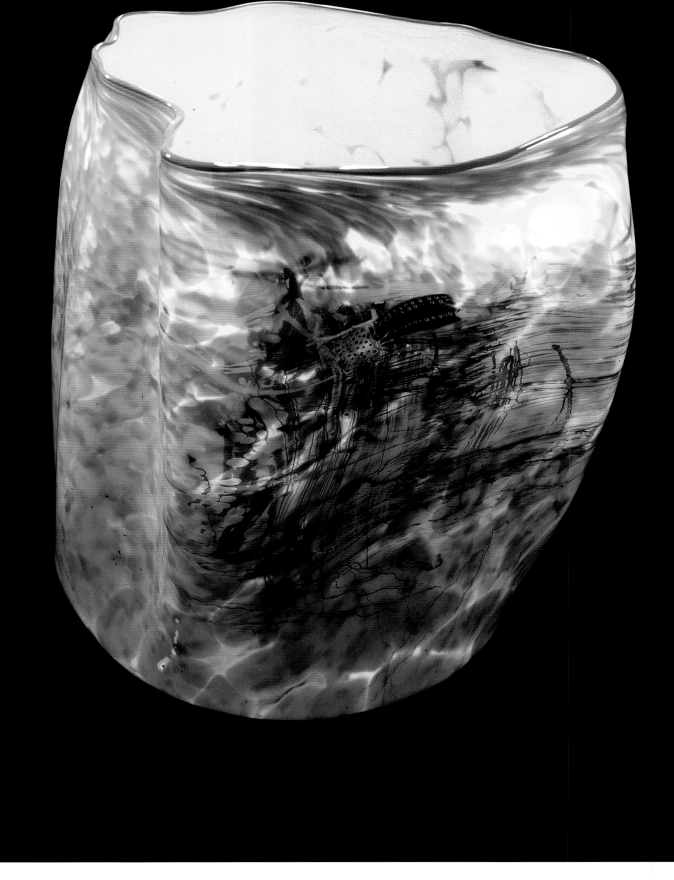

Chrome Yellow Soft Cylinder with Pink Lip Wrap, 1990, 24 x 19 x 17 inches

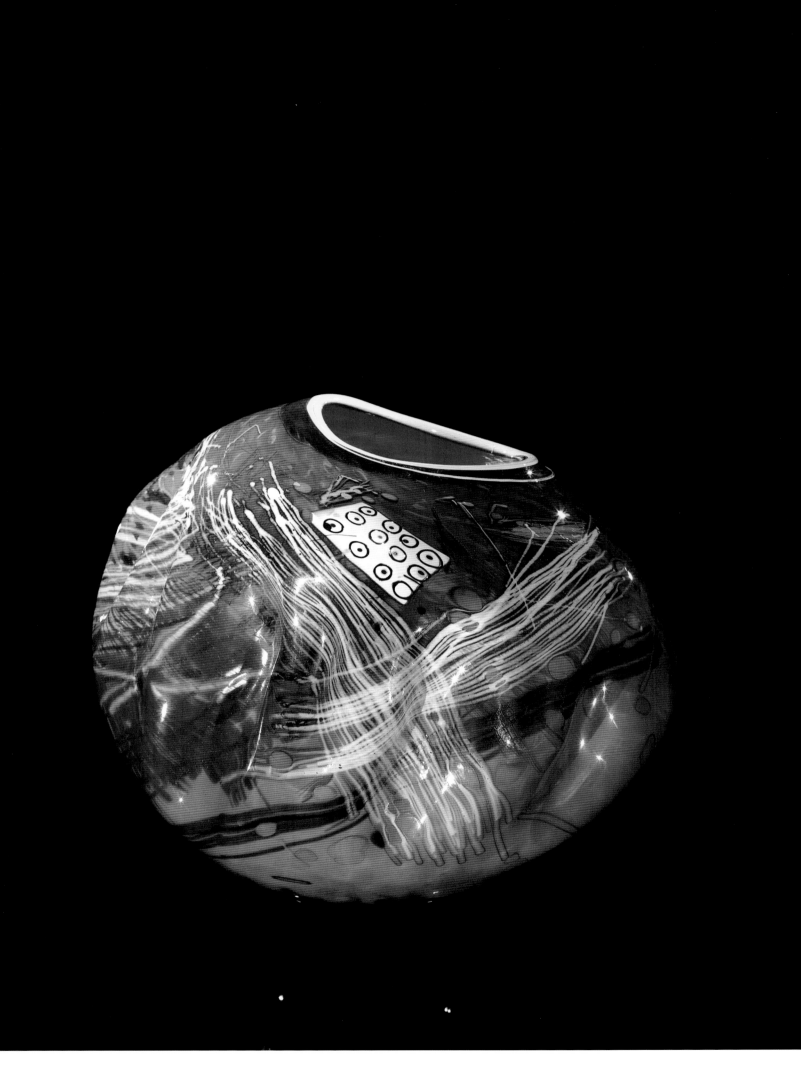

Cadmium Red Soft Cylinder with Green Lip Wrap, 1989, 10 x 12 x 9 inches

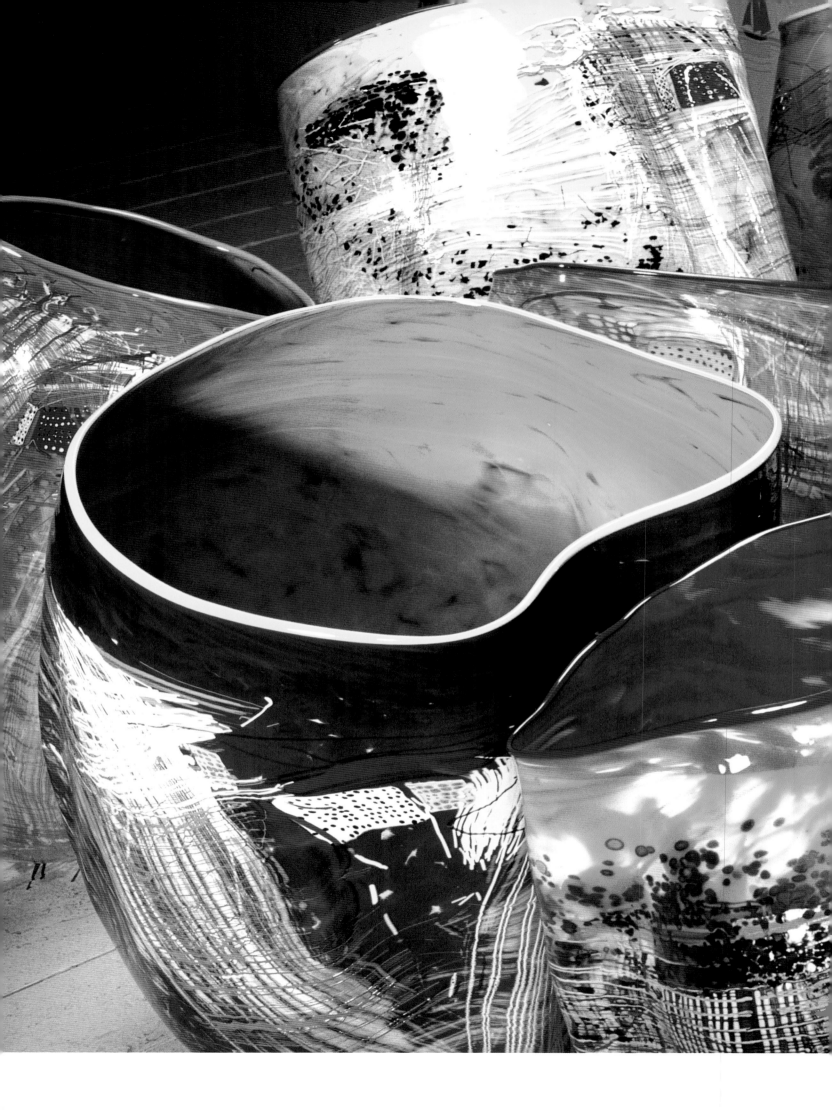

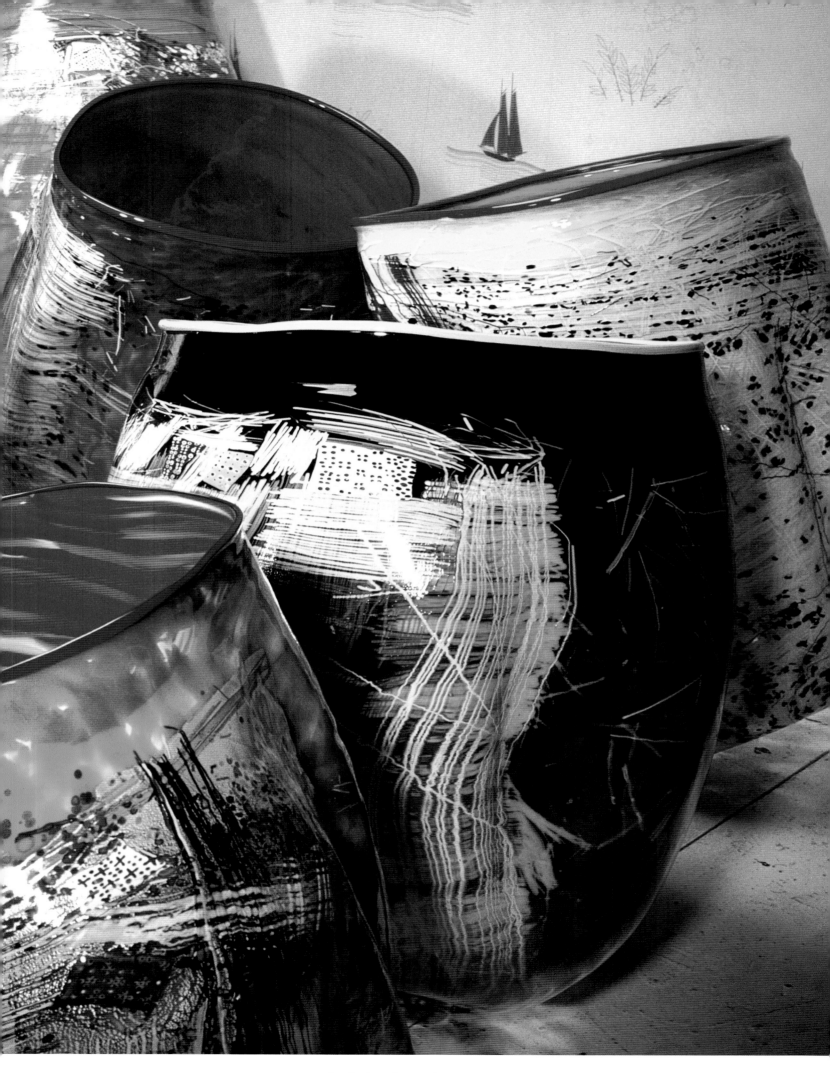

Soft Cylinders, The Boathouse, 1992

VENETIANS

Tensions abound in the *Venetians*. Every attachment seems to indicate flux, a relentless, organic force impinging on the physical integrity of the classic form. Hot glass simulates or is affected by natural properties and realities — its fluidity and the spontaneity of working equates to the mysterious metamorphoses of living organisms, while physical forces of gravity can be utilized or challenged to suggest an independent vitalism. The vegetative and biomorphic decoration and ornamentation of the *Venetians* seem to both confirm and contradict the laws of nature. The works expand aggressively into space, like a living and growing thing. And like living things, each work of the *Venetians* has an individual character, a personality if you will, much more so than Chihuly's other series. — *Ron Glowen, Venetians: Dale Chihuly, Twin Palms, 1989*

Lino Tagliapietra had been coming to Pilchuck for years, but because my work had always been unorthodox and asymmetrical, I had never worked with him. Anyhow, Lino and I decided to try to do something together. I began by designing a series that was a take-off on Venetian Art Deco pieces from the 1920s. I was able to sketch them and from these images Lino began to blow. We had a great time putting these together — always going further, pushing beyond what we had done in each previous piece. Handles changed to knots, prunts became claws, colors went from subtle to bright and forms from symmetrical to asymmetrical. — *Dale Chihuly, 1992*

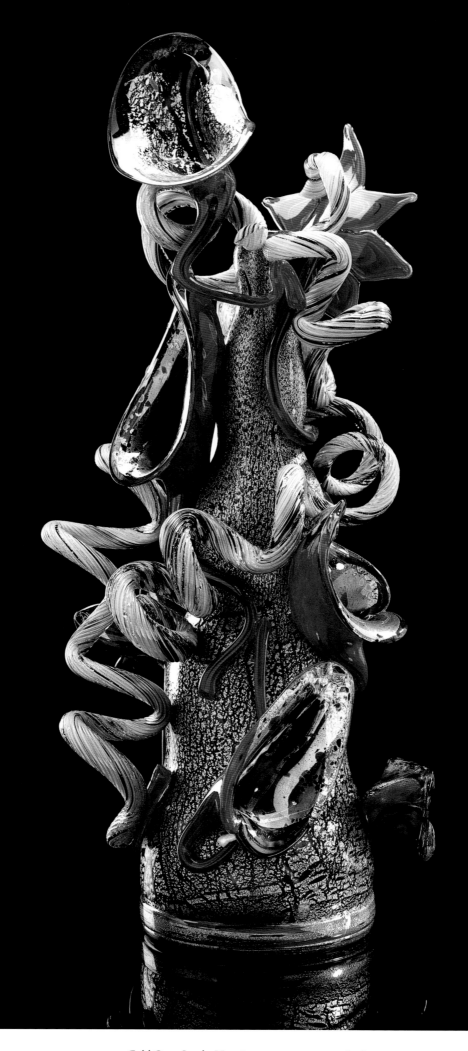

Gold Over Scarlet Venetian, 1990, 30 x 11 x 11 inches

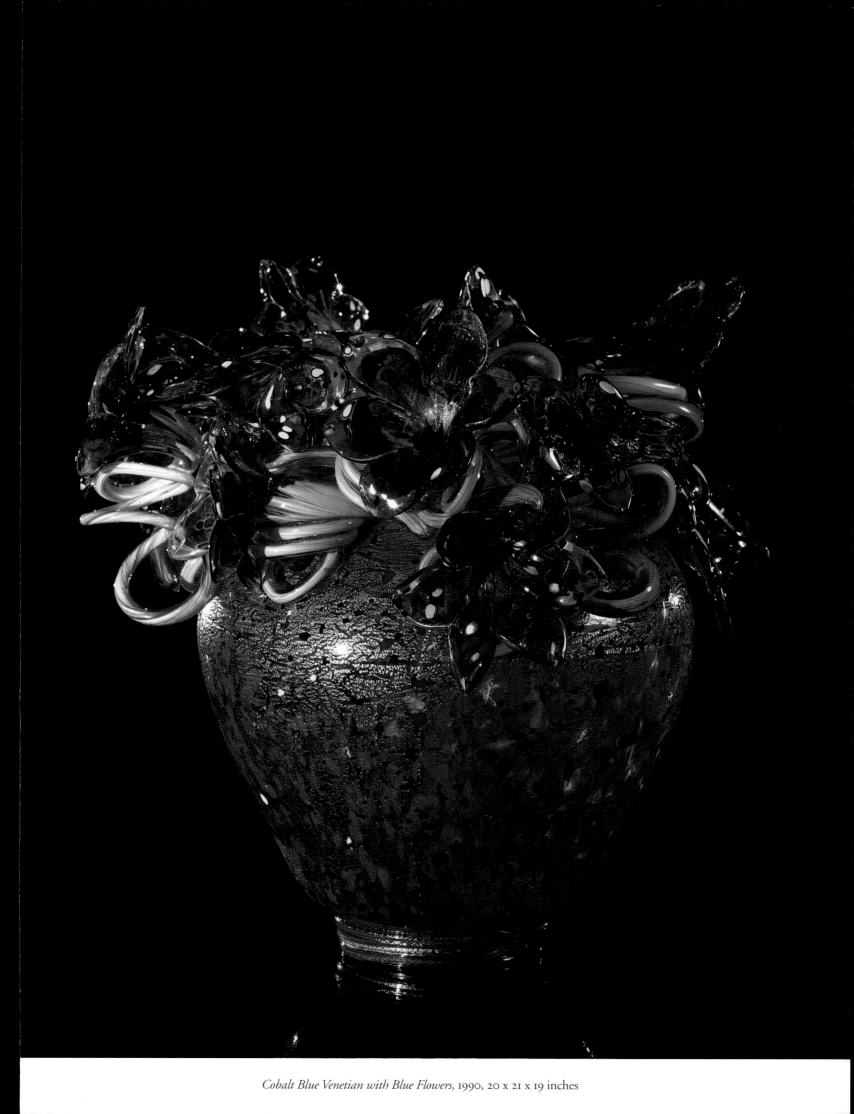

Cobalt Blue Venetian with Blue Flowers, 1990, 20 x 21 x 19 inches

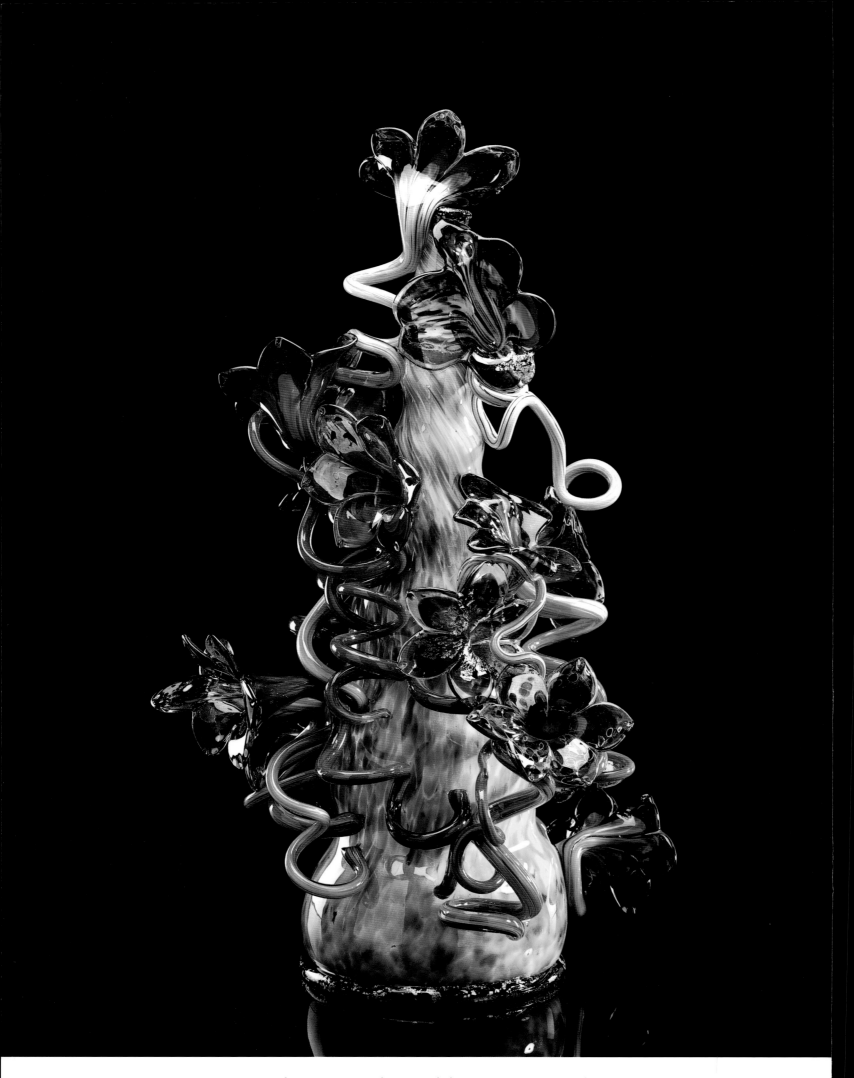

Leaf Green Venetian with Variegated Flowers, 1990, 32 x 19 x 15 inches

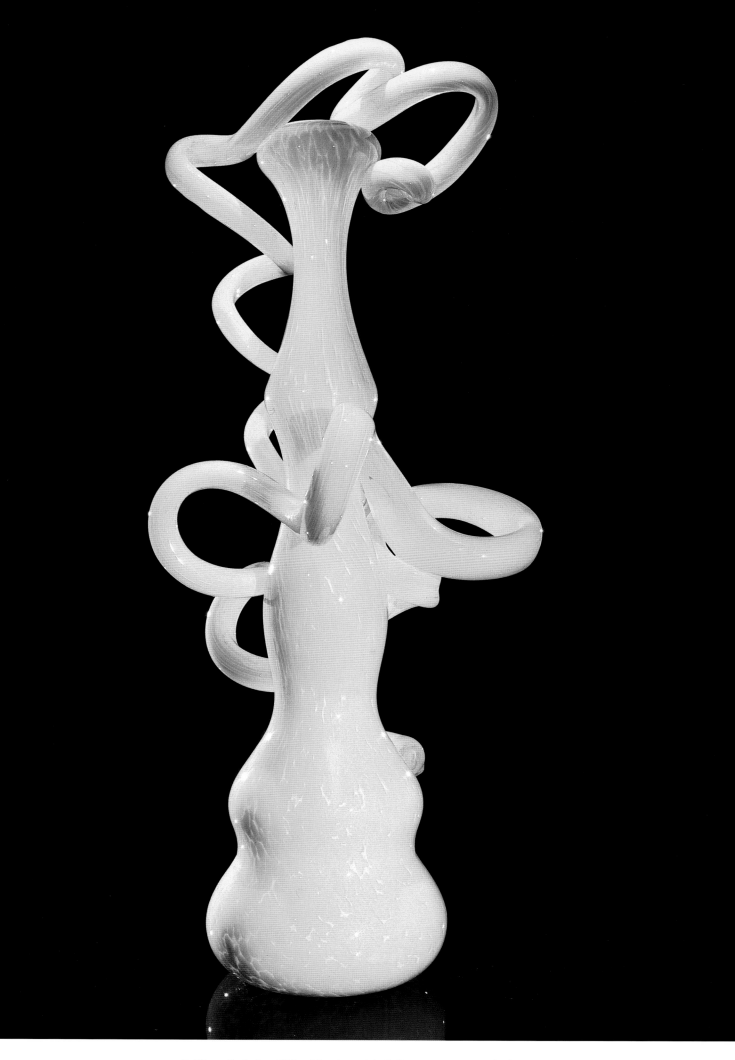

Brilliant Cadmium Yellow Venetian with Coils, 1991, 38 x 16 x 15 inches

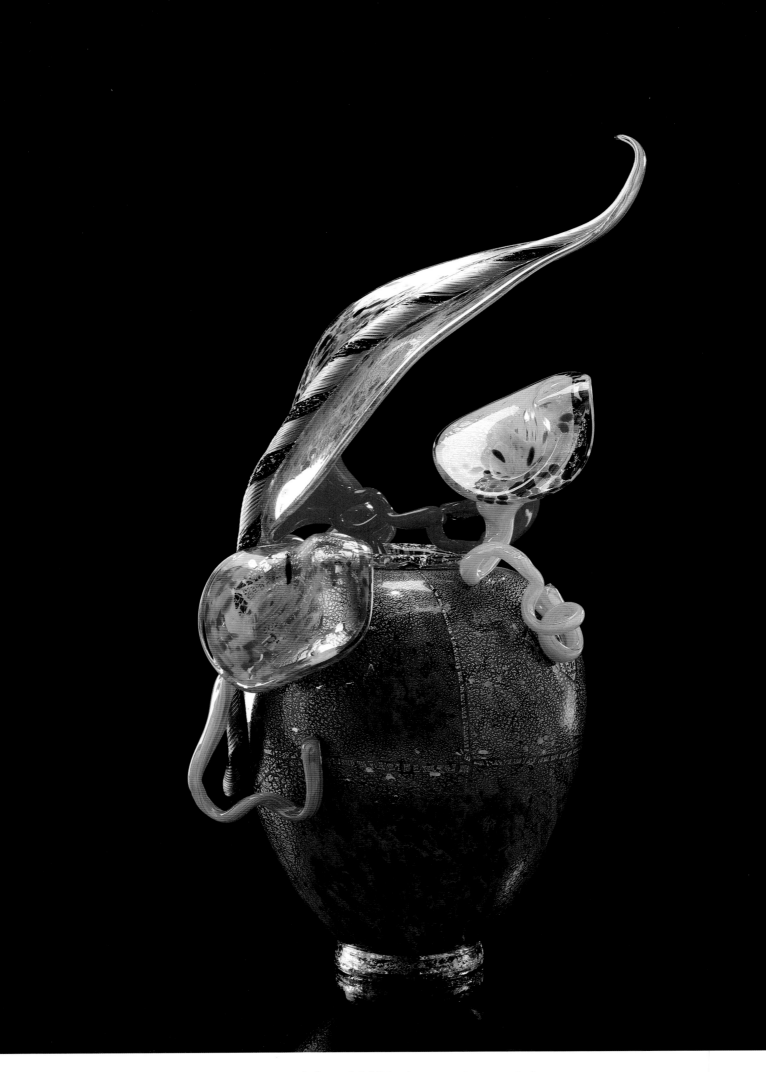

Royal Blue and Gold Venetian, 1990, 28 x 14 x 12 inches

Venetian Drawing, 1992, 30 x 22 inches, Acrylic on paper

Venetian Drawing, 1990 30 x 22 inches, Charcoal, watercolor and pigment on paper

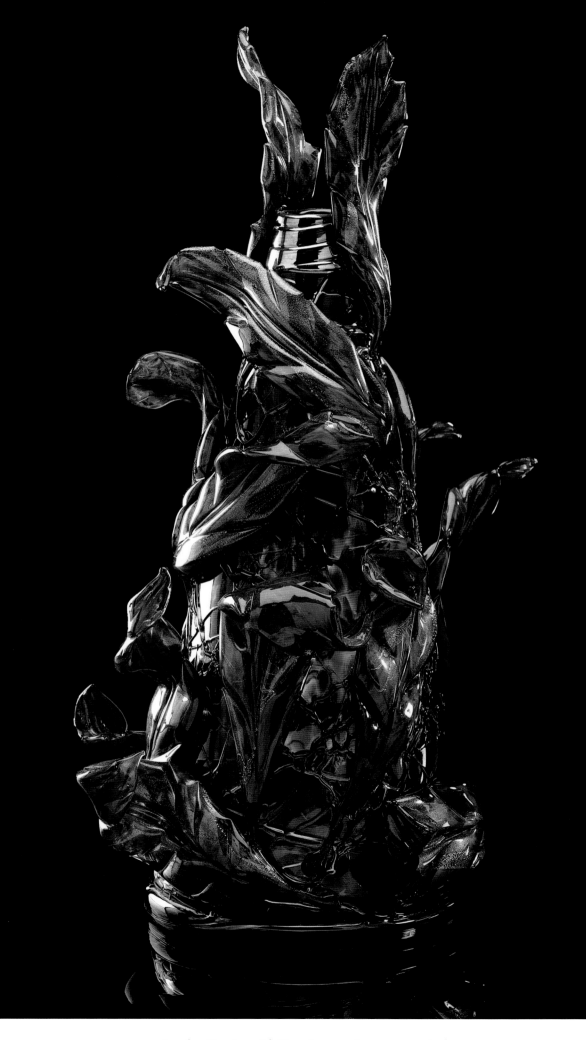

Amethyst Venetian with Green Leaves, 1989, 25 x 12 x 13 inches

IKEBANA

Mr. Chihuly uses the word *ikebana* in most of his titles, and many of these works
emulate the Japanese art of subtle but intensely stylized flower arranging. . . . All of the
work reflects the painterly chromatic complexity of Venetian glass and the sensuous
curves of Art Nouveau, whose sometimes outlandish use of floral forms Mr. Chihuly is
perfectly willing to match. — *Holland Cotter, The New York Times, 1993*

Chihuly grew up surrounded by flowers; his mother has a passion for gardening. . . .
It is not too surprising that Chihuly has periodically turned to floral motifs. . . .
To embellish his *Venetians* and complement and emphasize their larger scale, Chihuly
created a series of elongated stems and blossoms, called *Ikebana,* after the stylized
beauty of Japanese floral arrangements and reminiscent of the carved wood, gilt lotus
blossoms that he admired on visits to Buddhist temples in Japan. — *Patterson Sims,
"Scuola di Chihuly: Venezia and Seattle," Dale Chihuly Installations: 1964–1992,
Seattle Art Museum, 1992*

I was lucky to have not only Lino Tagliapietra, one of the really extraordinary
glass masters in the world, but also Ben Moore, who is almost a son to Lino. Benny
organized the teams for the *Venetians* series with Lino as the maestro. We would
bring together anywhere from 12 to 18 glass blowers, primarily from Seattle, to try to do
the most extreme pieces that I imagined they would be willing to do. Each session
would get more elaborate. The teams kept getting bigger and wilder, and the pieces
became more extreme. I would make a drawing and Lino would look at it and shout
out a few orders to Benny in Italian — even though Lino does speak English.
One thing led to another. — *Dale Chihuly, 1992*

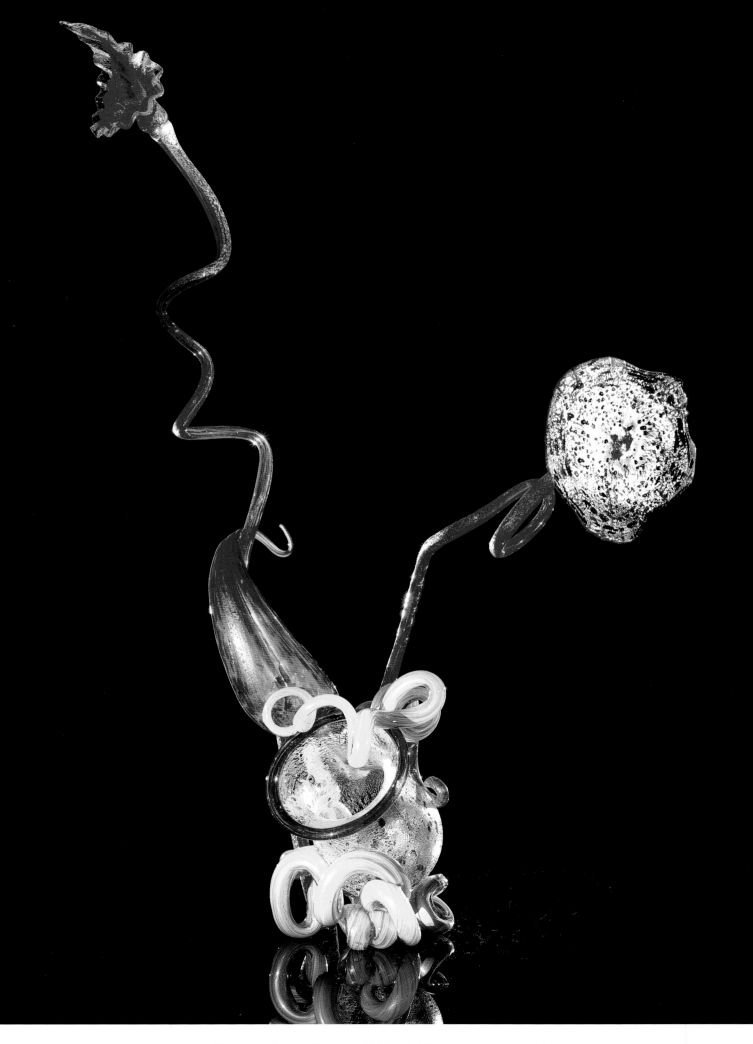

Chartreuse Venetian Ikebana with Two Red Stems, 1991, 54 x 25 x 30 inches

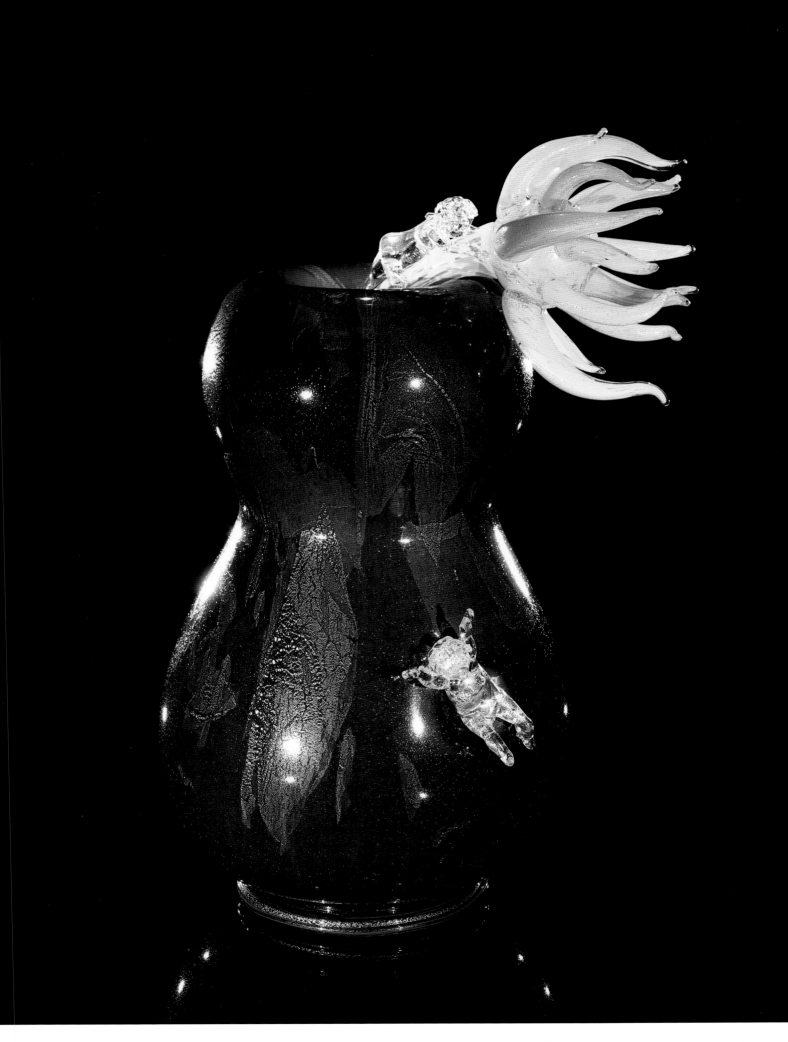

Plum Putti Ikebana with Yellow Putti Stem, 1991, 27 x 16 x 13 inches

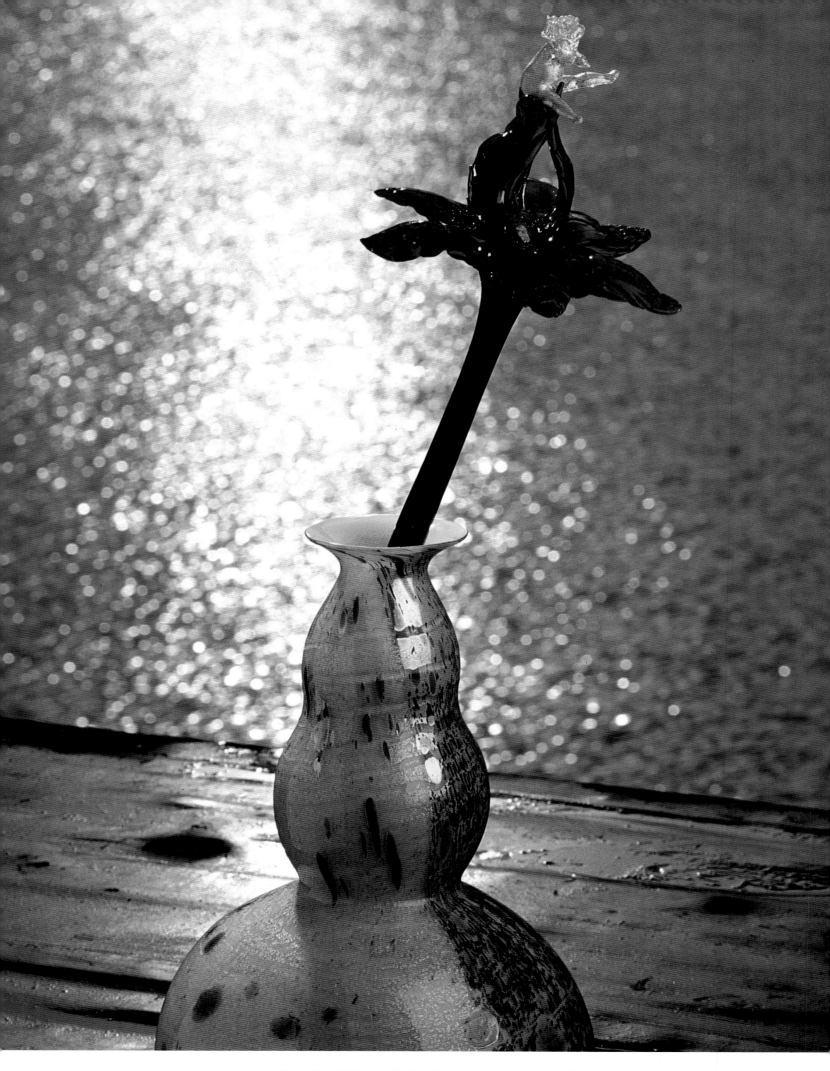

Gilded Yellow Ikebana with Putti Flower, 1991, 43 x 16 x 15 inches

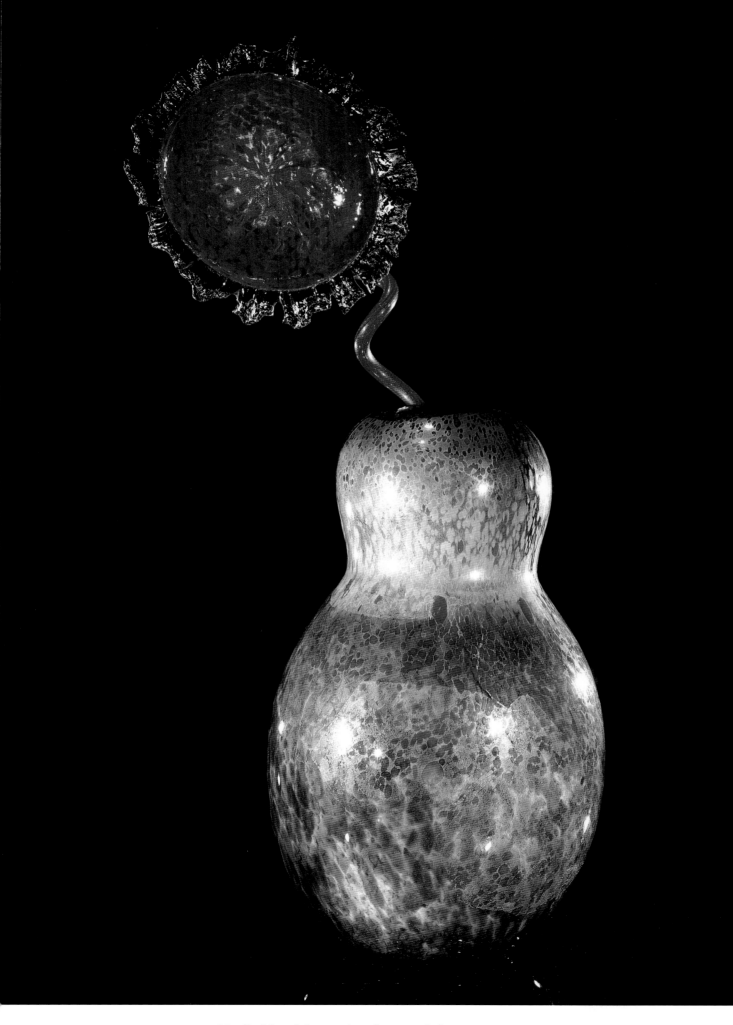

Metallic Silver Ikebana with Cadmium Red Flower, 1992, 45 x 24 x 16 inches

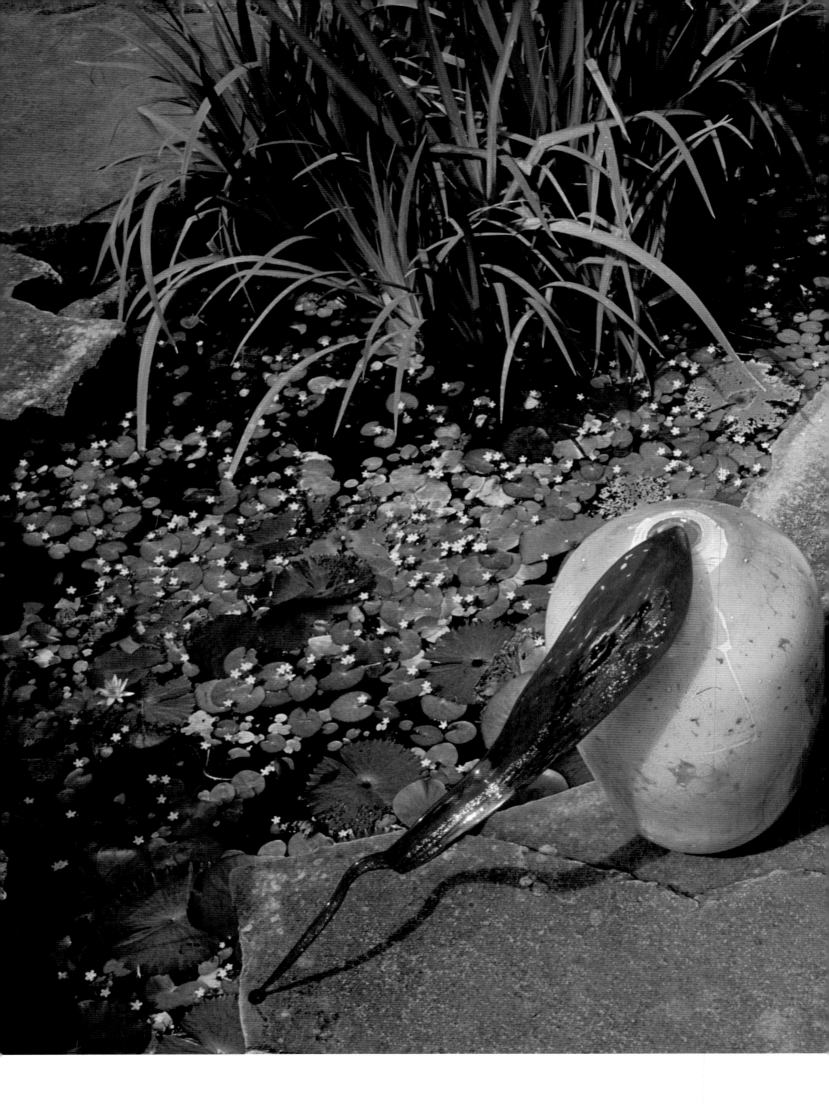

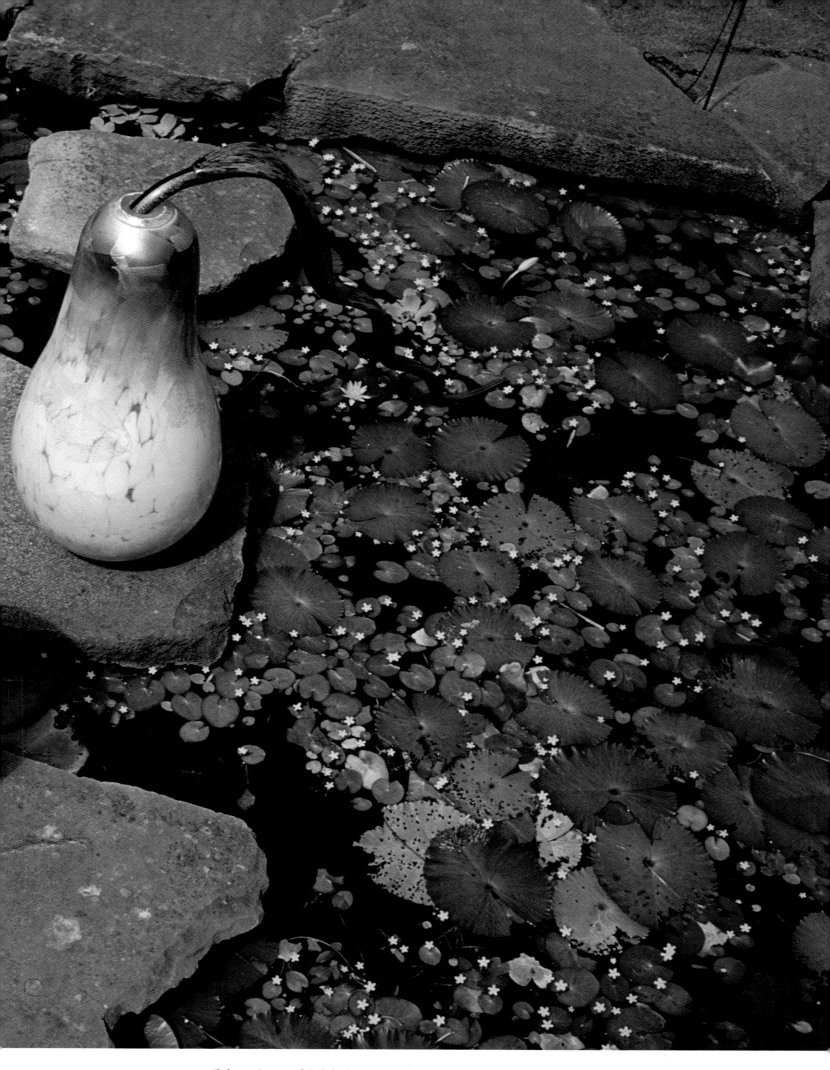

Ikebana Courtyard, "Chihuly Courtyards," Honolulu Academy of Arts, 1992

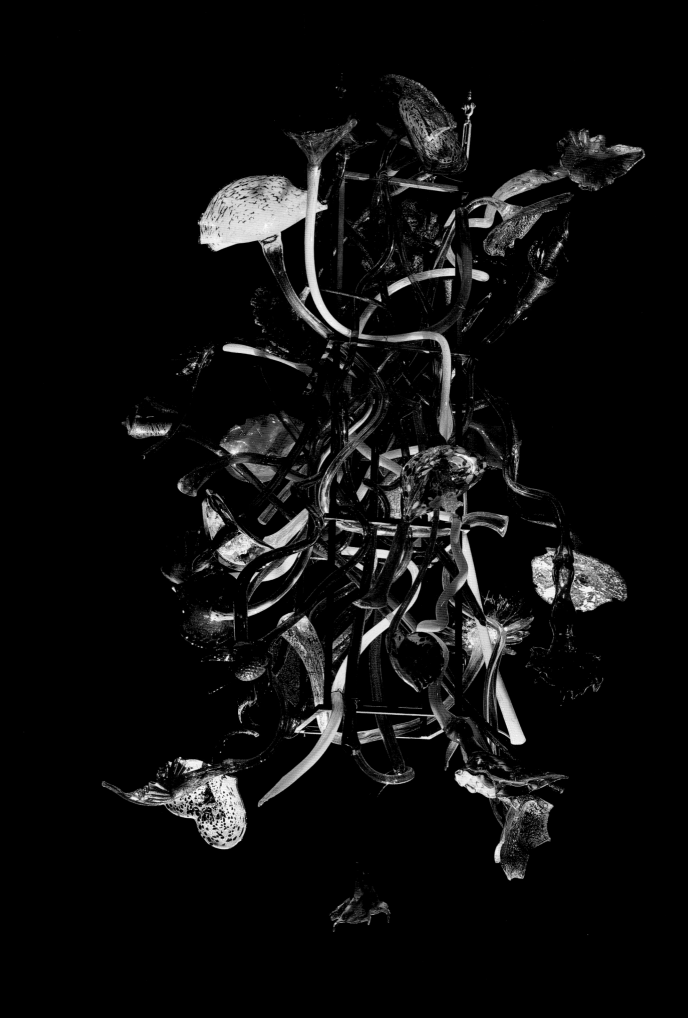

Ikebana Chandelier, 1992, 84 x 36 x 36 inches

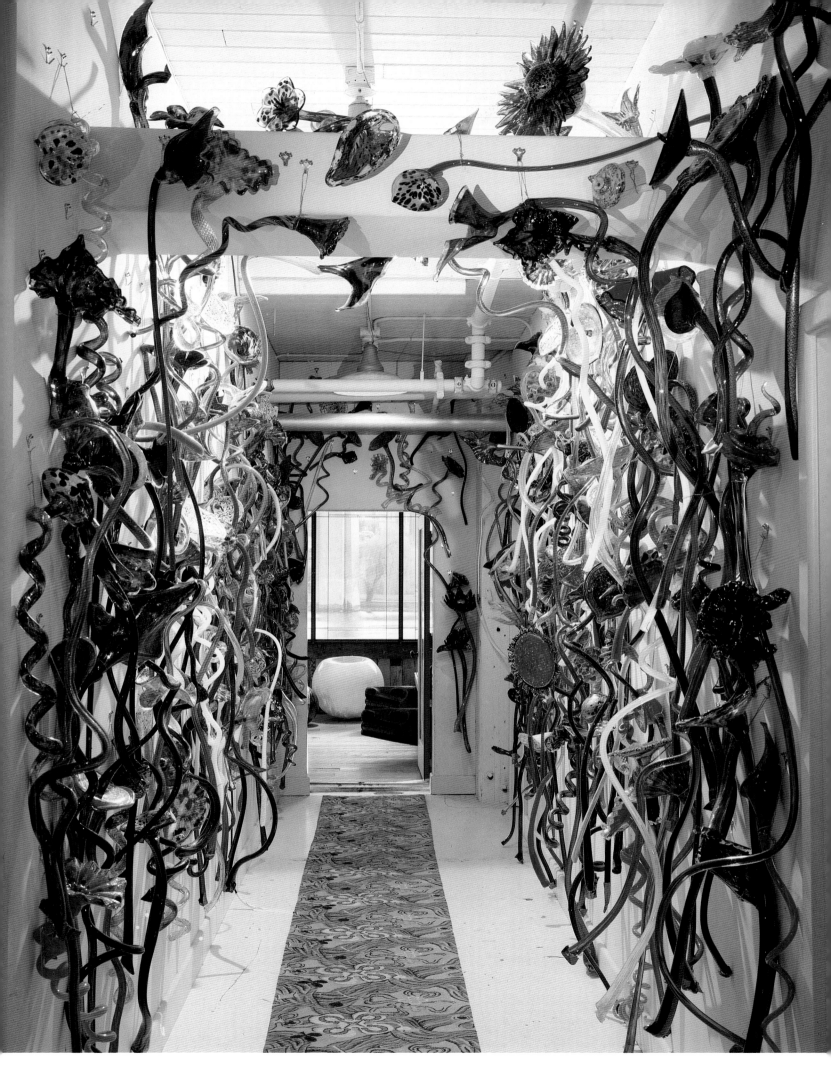

Ikebana Hallway, The Boathouse, 1991

INSTALLATIONS

I'm fortunate that my work appeals to such a broad range of people. I think it's more accessible than a lot of public work. Maybe that has to do with the material. People for centuries have been fascinated with glass. It transmits light in a special way, and at any moment it might break. It's the most magical of all materials. — *Dale Chihuly, 1992*

Polychromatic neon tubes are frozen into 300 pound blocks of ice. As the ice melts (and rapidly so in Honolulu), a visual transformation occurs that mirrors the metamorphosis of ice to water, lending the work aesthetic and physical implications. This duality of science and art is not a conflict, but rather a carefully cultivated partnership that comes from a mastery of the materials and a knowledge of their inherent properties. ¶Chihuly is cognizant of the nature of glass — from its aesthetic potential to the physical structures, properties and limitations of the fragile material. Glass is indeed a complex substance, with seemingly contradictory properties: ephemeral and eternal, clear and opaque, decorative and functional, fluid and brittle, material and immaterial, solid and liquid. Chihuly draws on these oxymoronic qualities, shaping masterpieces that are both beautiful to the eye and indicative of the skill and expertise that fostered their creation. Glass blowing, an intense and difficult technique involving hot and hazardous conditions, permits a small margin for the all-important element — chance. On this border of controlled accident, Chihuly not only operates, but prospers. — *Sarah E. Bremser, Chihuly Courtyards, Honolulu Academy of Arts, 1992*

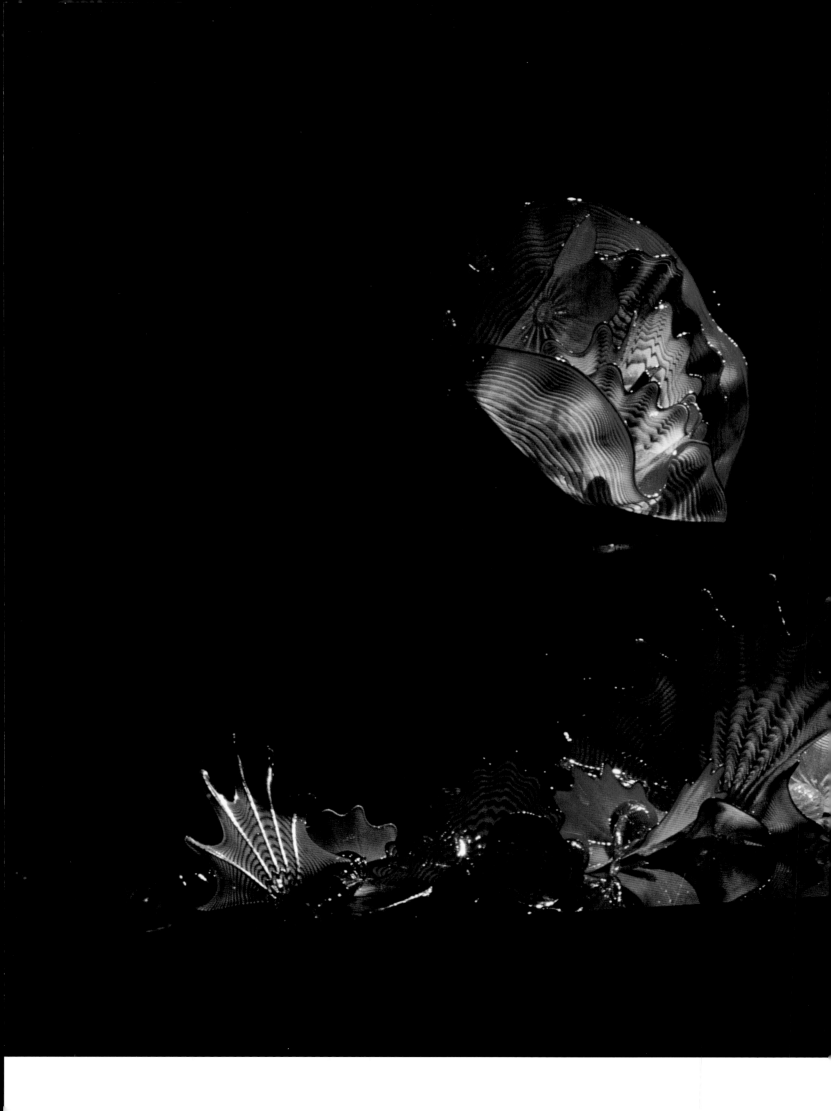

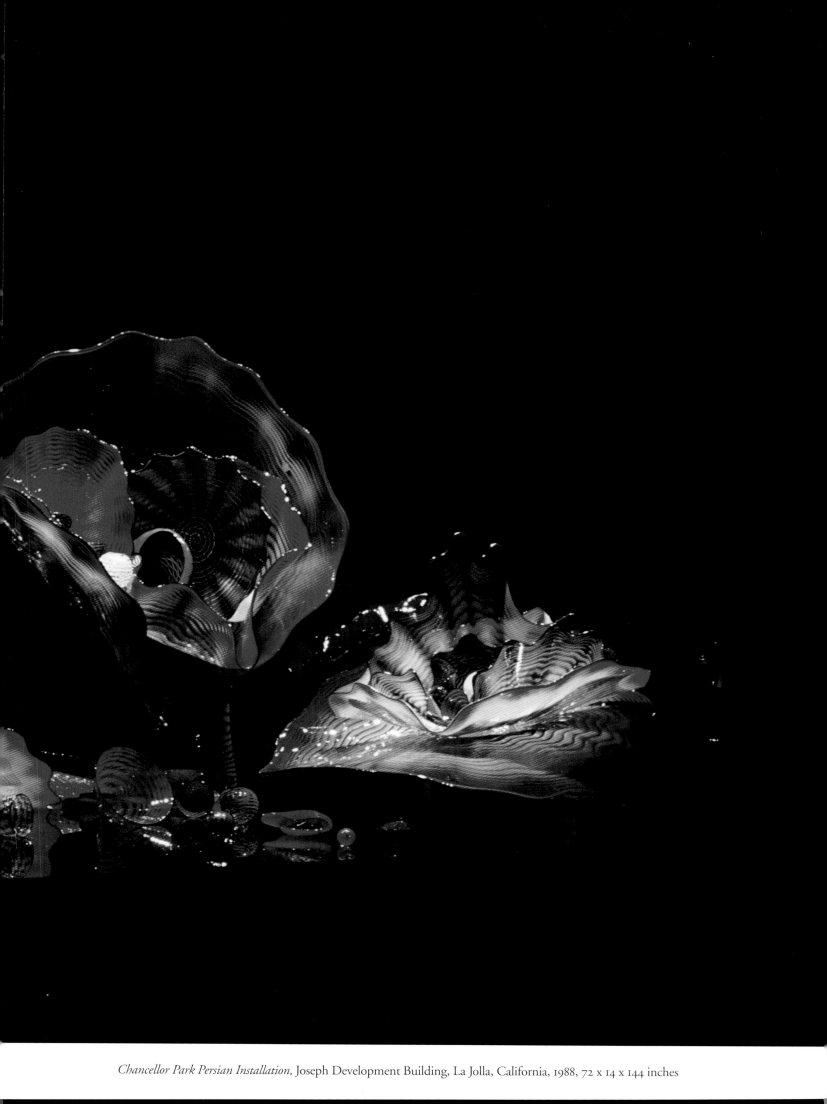

Chancellor Park Persian Installation, Joseph Development Building, La Jolla, California, 1988, 72 x 14 x 144 inches

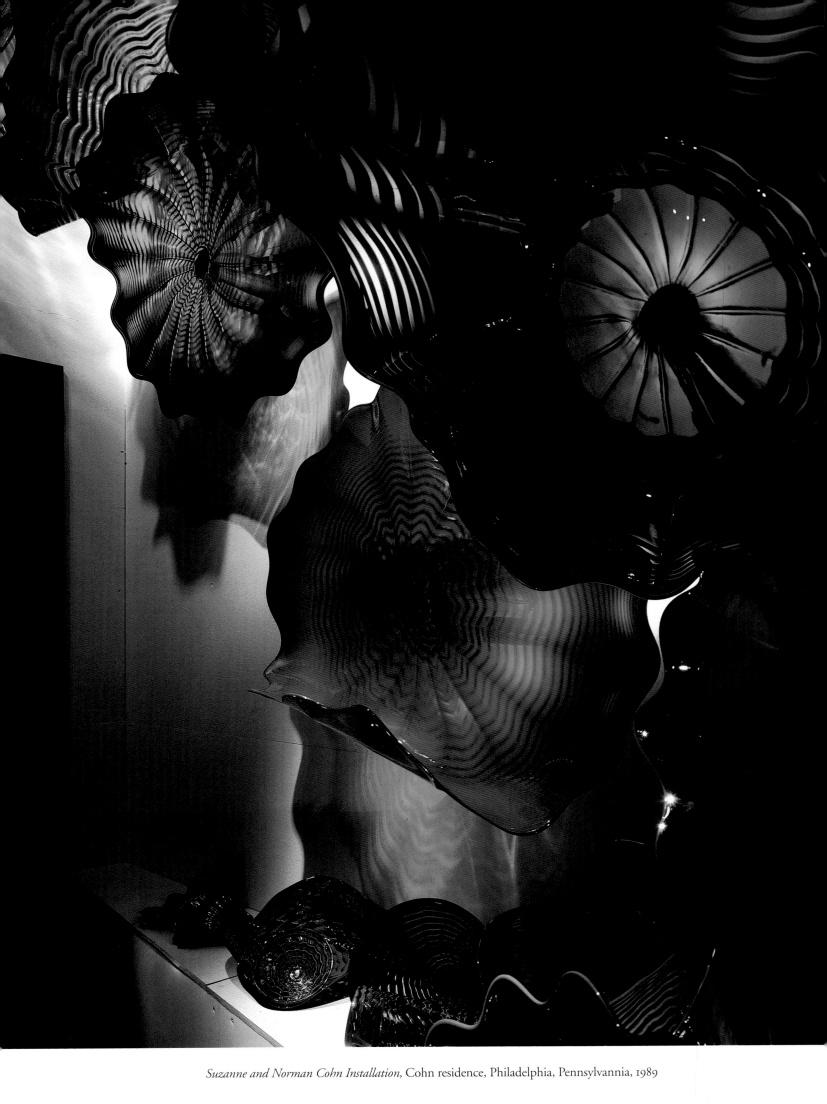

Suzanne and Norman Cohn Installation, Cohn residence, Philadelphia, Pennsylvannia, 1989

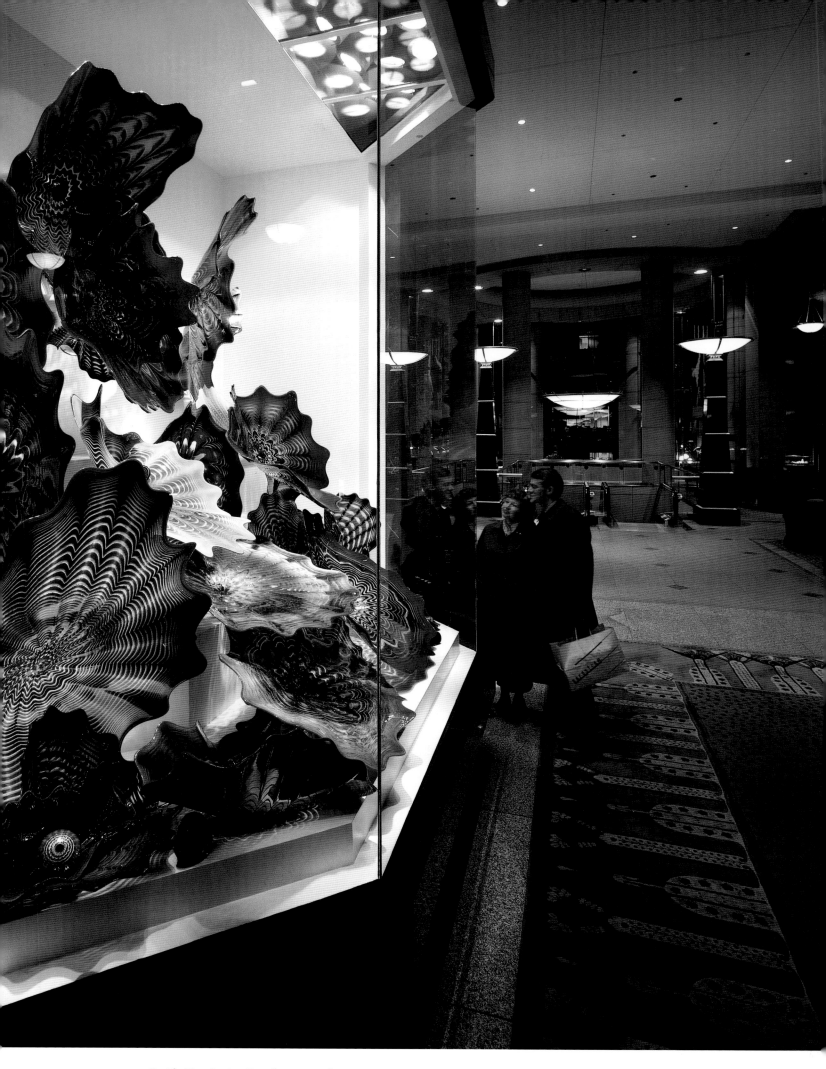

Pacific First Persian Installation, Pacific First Centre, Seattle, Washington, 1991, 120 x 144 x 90 inches

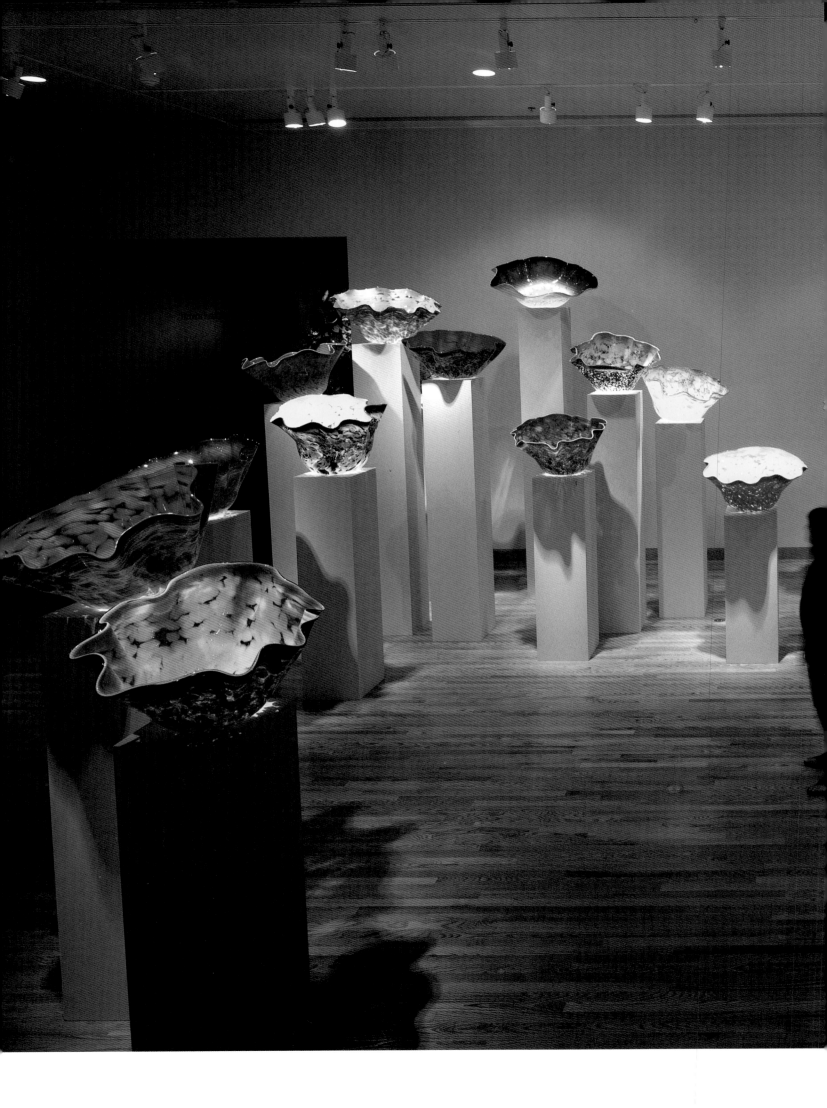

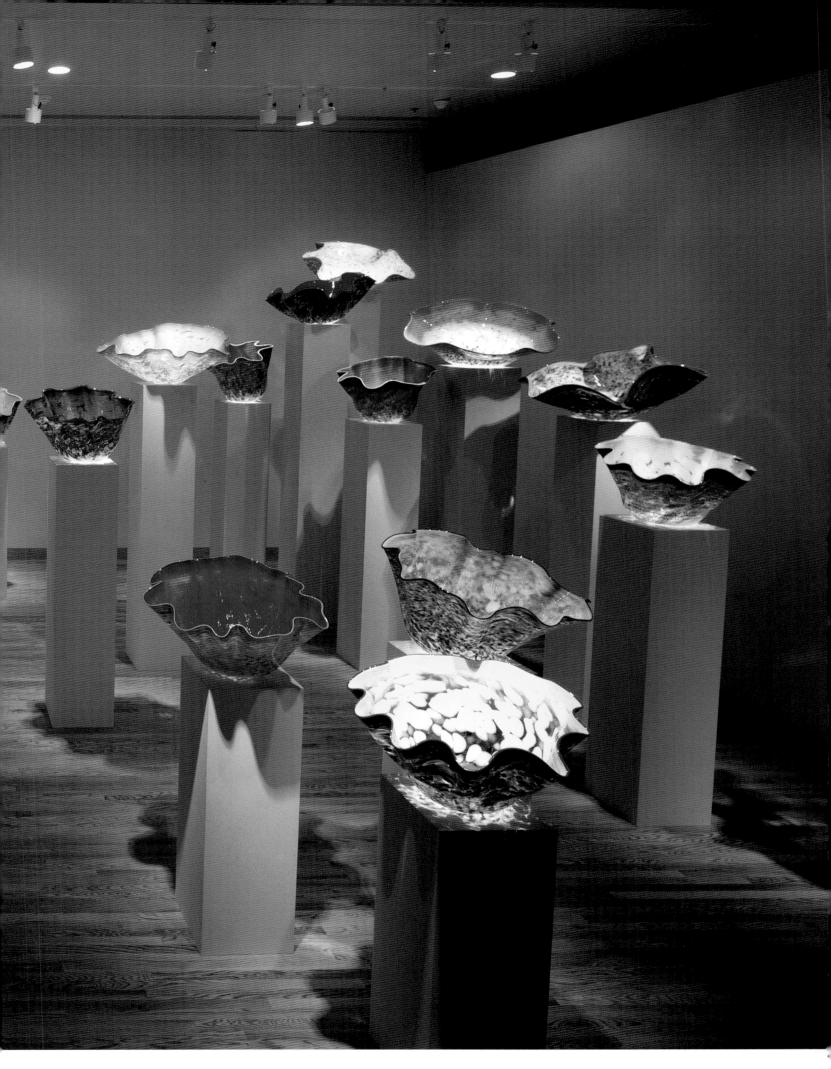

Macchia Forest, Seattle Art Museum, 1992, 45 x 25 x 10 feet

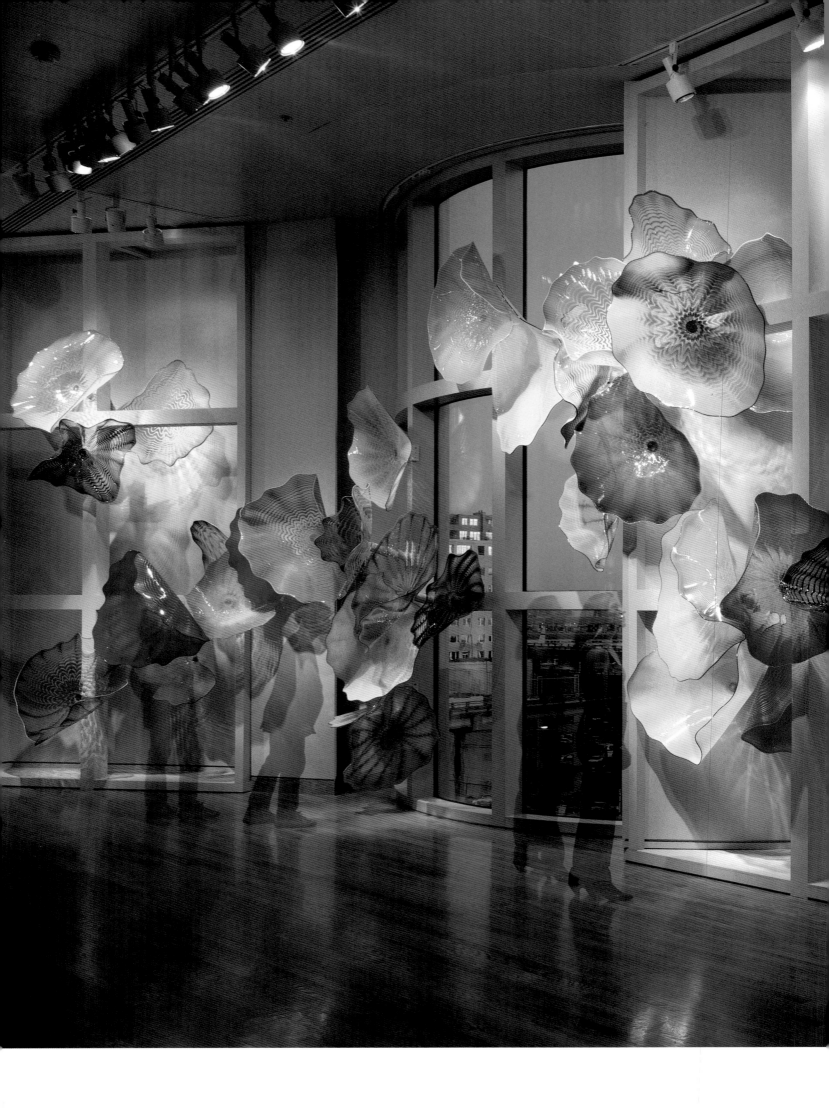

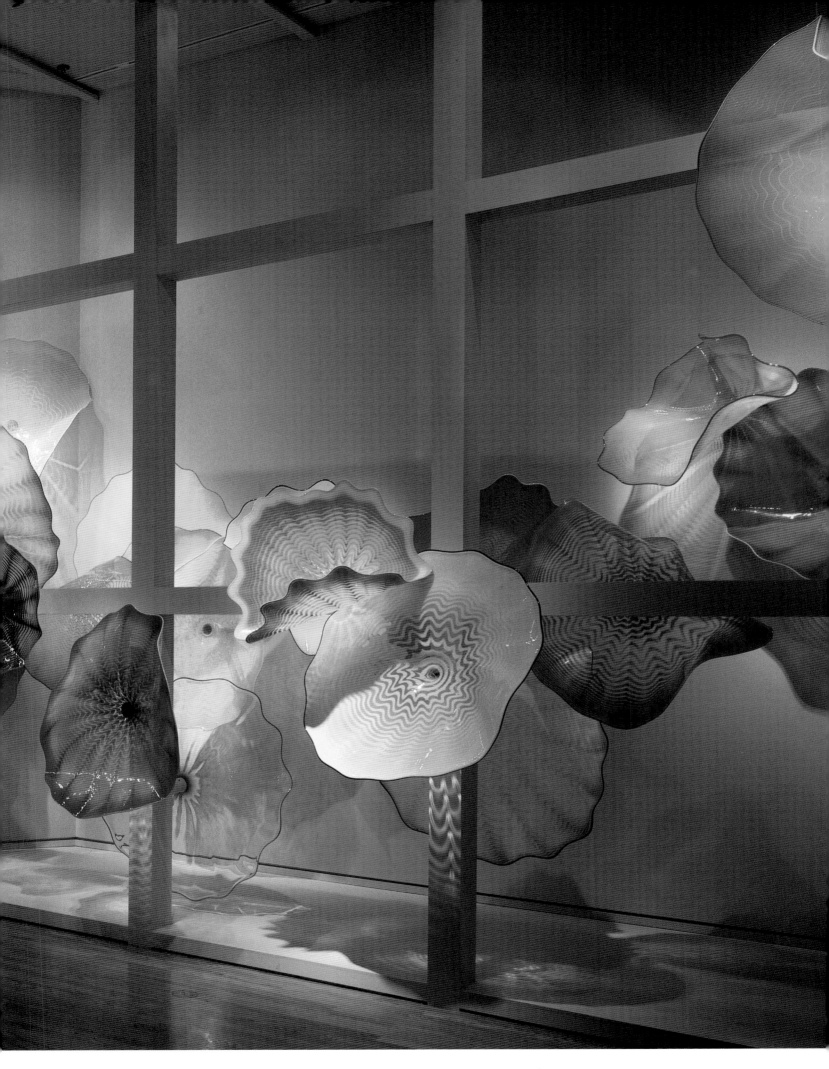

Venturi Window, Seattle Art Museum, 1992, 48 x 16 x 7 feet

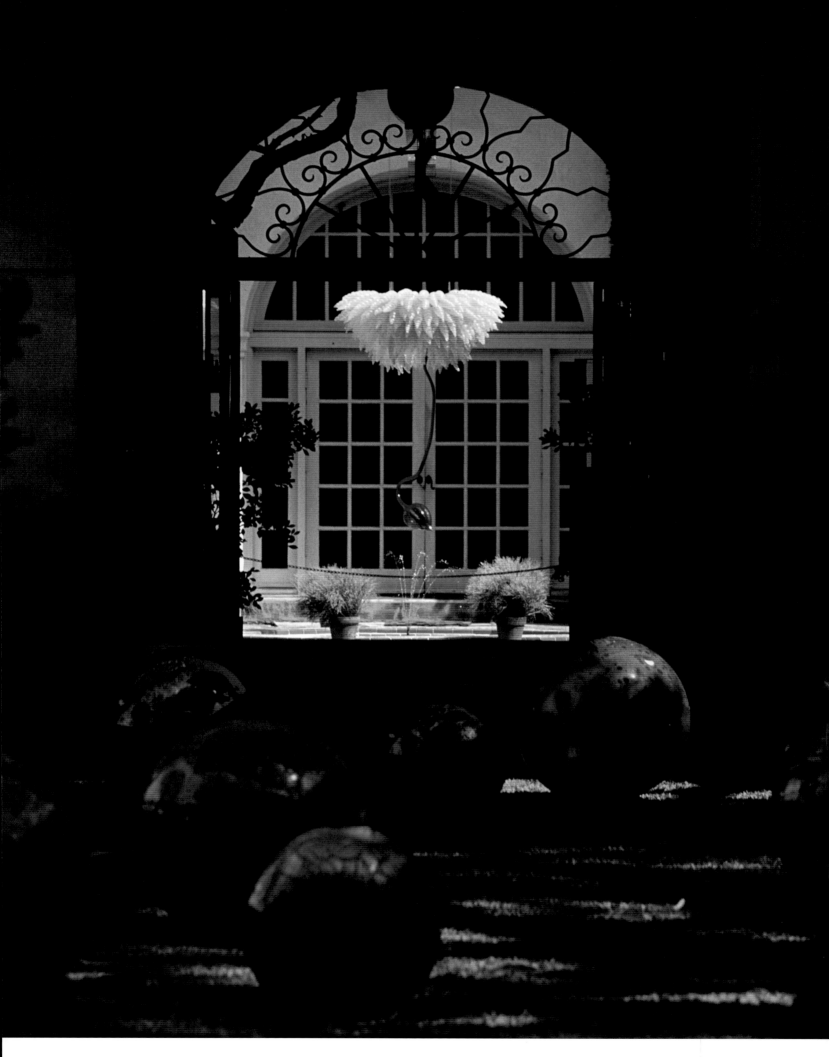

Honolulu Academy of Arts Chandelier, "Chihuly Courtyards," 1992, 7 x 3 x 3 feet

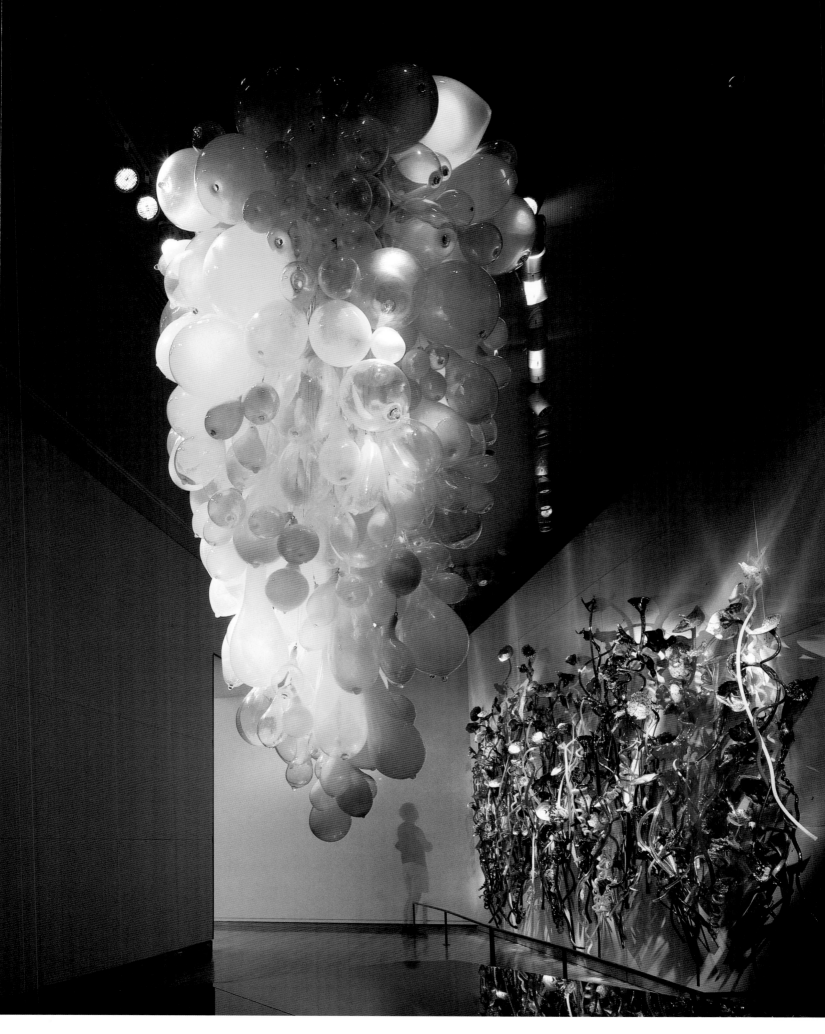

Seattle Art Museum Chandelier, 1992, 8 x 5 x 4 feet

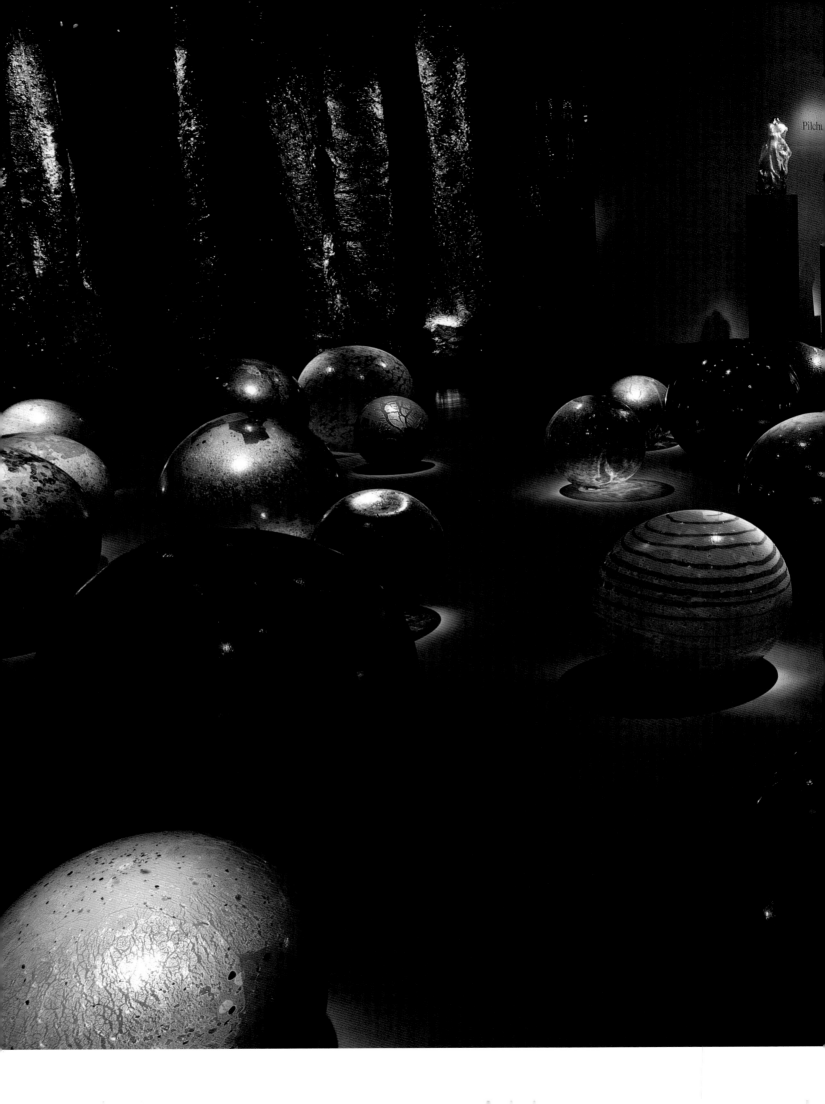

Pilchu

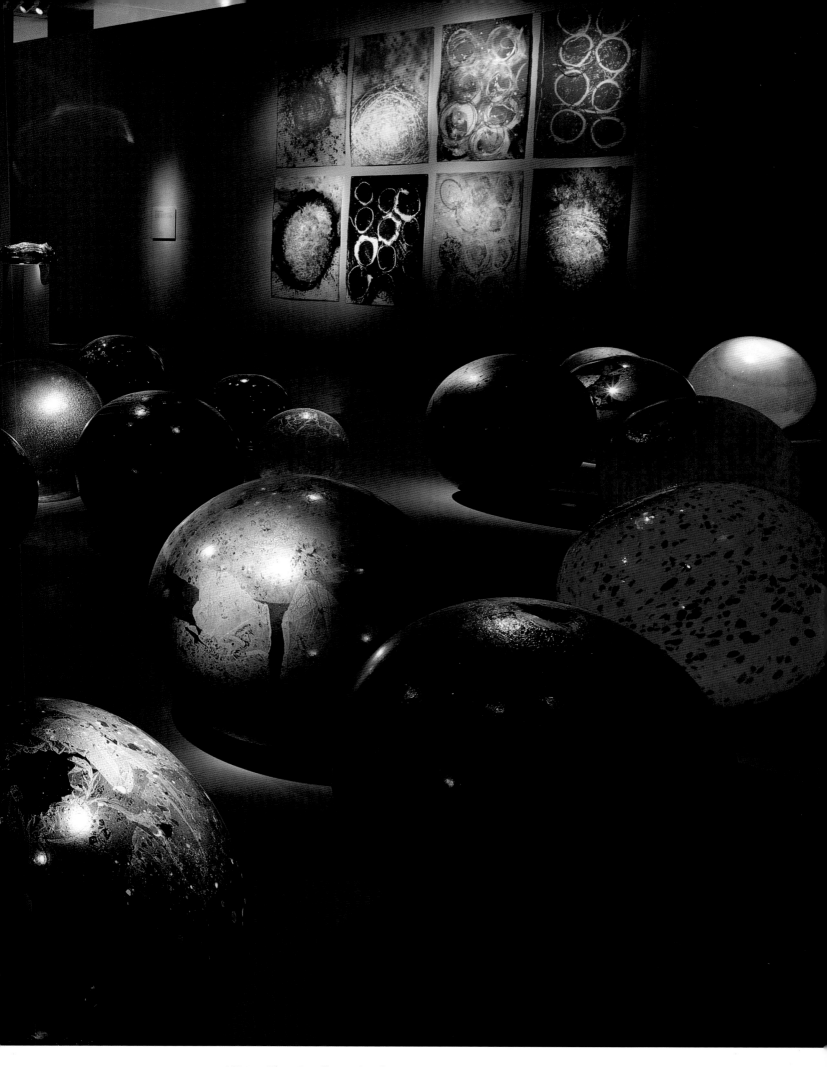

Niijima Floats Installation, Seattle Art Museum, 1992, 39 x 39 x 42 feet

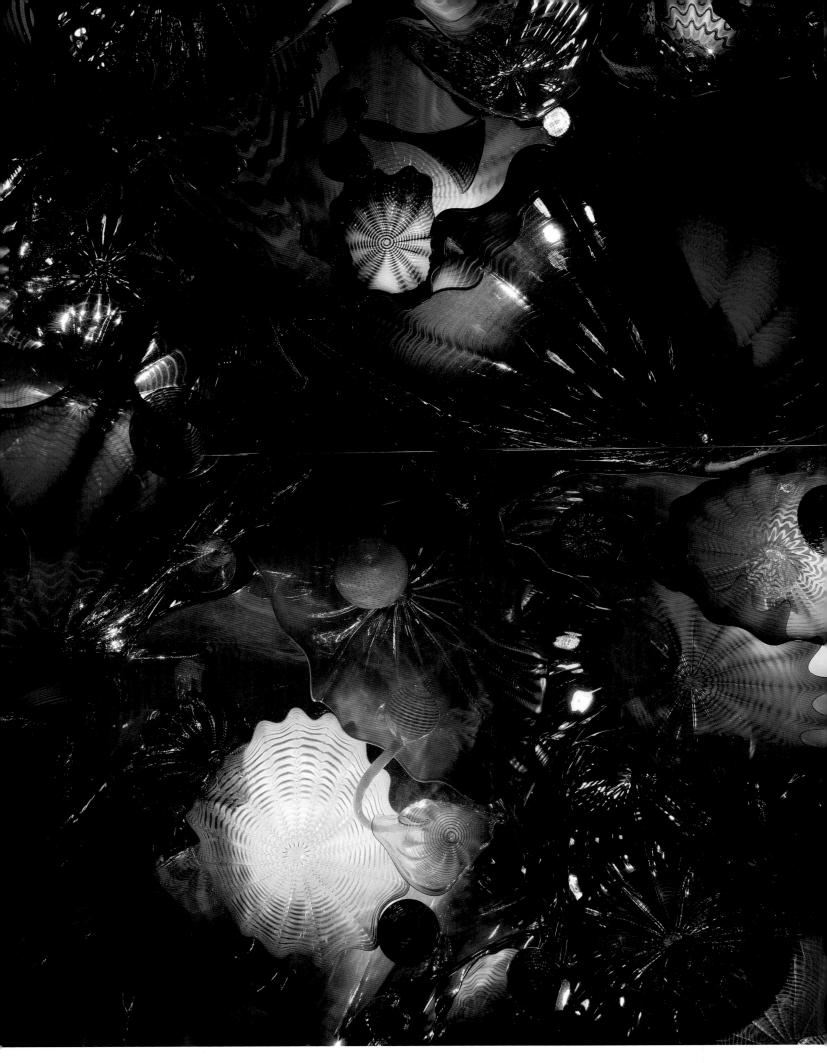

Persian Ceiling, detail

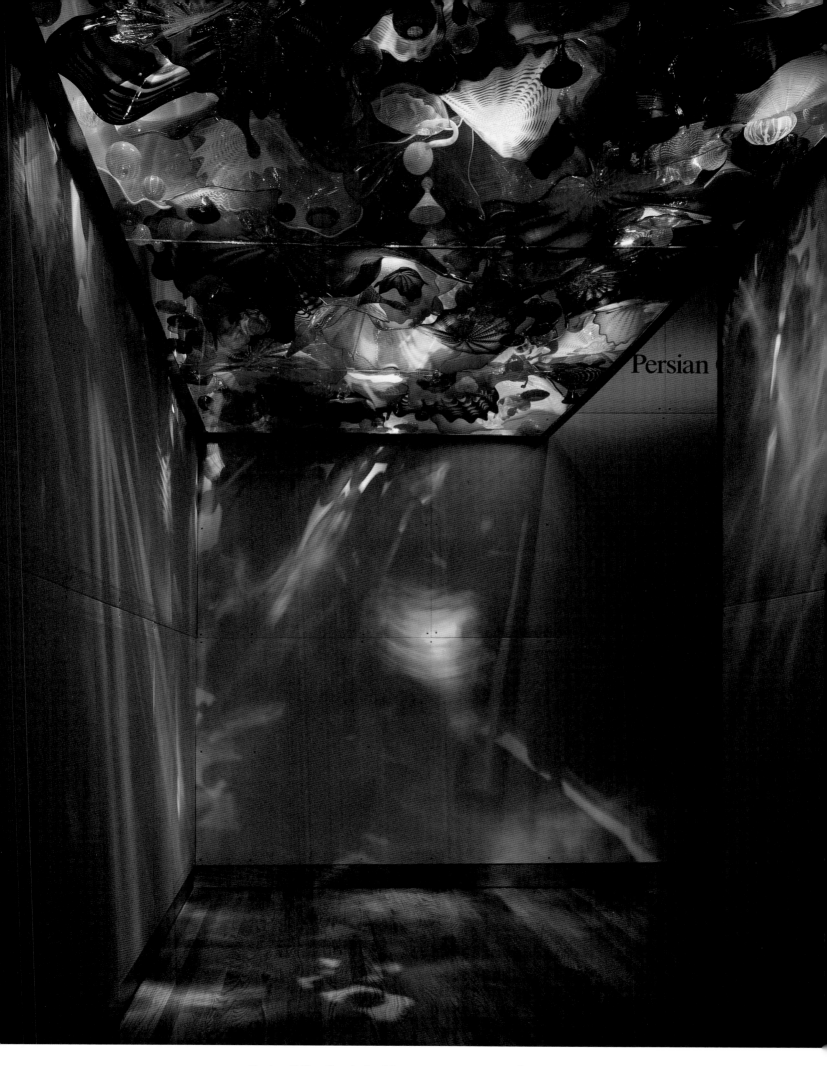

Persian Ceiling, Seattle Art Museum, 1992, 12 x 10 x 6 feet

Honolulu Ice and Neon, "Chihuly Courtyards," Honolulu Academy of Arts, 1992 (based on *20,000 Pounds of Ice,* a 1971 collaboration with James Carpenter)

NIIJIMA FLOATS

The *[Niijima] Floats*. . . are really quite daring: They sit directly on the floor, spotlit, like benthic organisms under a diver's spotlight or jellyfish washed up on a beach or (as Chihuly suggests through their names) glass fishing-net floats. Their surfaces — several of the *Floats* feature a gold-leaf technique developed during the *Venetian* series as well as streams of tiny air bubbles — suggest swirling current, pebbly stream beds and biological organisms. Their coloring is as richly layered as Japanese lacquer or an undersea reef. It's this tension — between the fantasy world of high artifice and the natural world of high artifice and the natural world in its infinite mystery and variety — that gives these most recent works a greater significance. — *Justin Spring, Artforum, 1992*

I've never done anything like the *Niijima Floats*. They are probably the most monumental-looking since there's no reminiscence of a container shape. Just because they are so goddamn big, the *Floats* are technically, or say, physically, the most difficult things that we have ever done. Even though a sphere or a ball is about the easiest form you can make in glass, when you get to this scale, up to 40 inches in diameter, it becomes extremely difficult. — *Dale Chihuly, 1992*

Chihuly has said that it is the process of glass blowing more than the material that fascinates him. In Chihuly's oeuvre, the *Niijima Floats* are the most direct expression of the glass blowing process, since the sphere is the form most naturally created on the blowpipe. It is also an archetypal shape with rich symbolic power. The *Floats* can transcend their unassuming shapes and become celestial orbs. These sculptures might also be viewed as paintings, as works to be looked at and into. — *Karen S. Chambers, 1992*

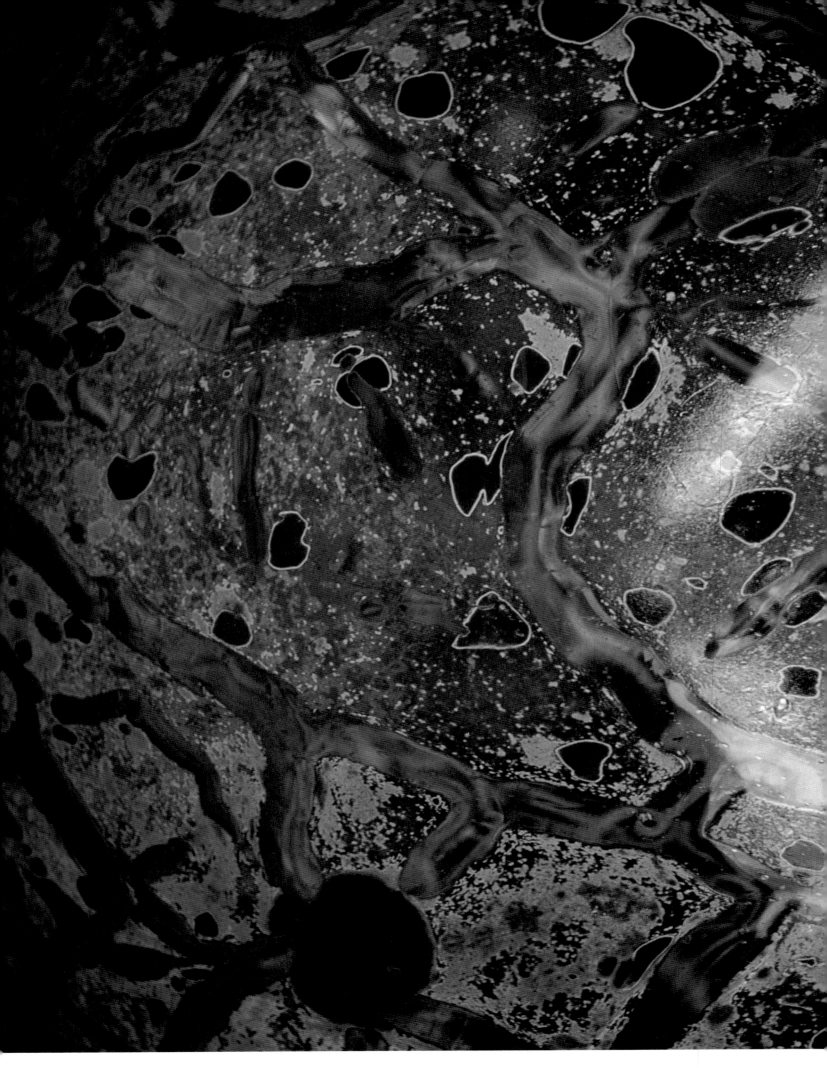

Niijima Float, detail, 1992

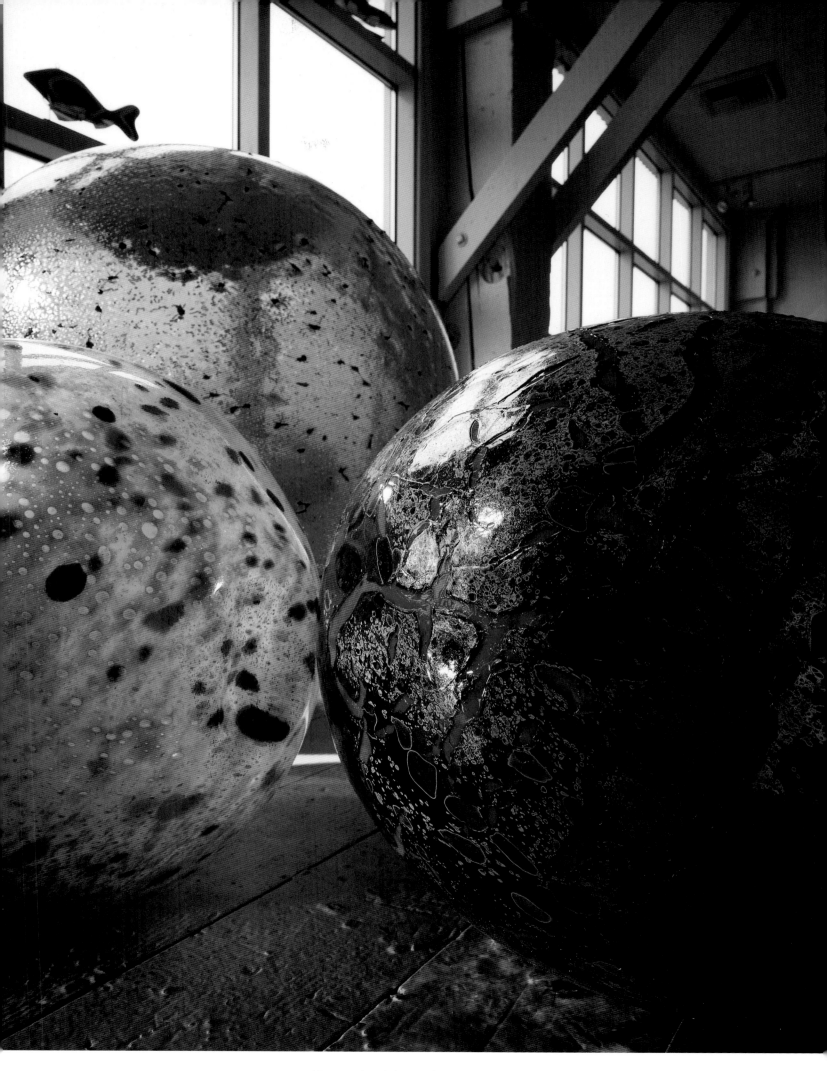

Niijima Floats, The Boathouse, 1991

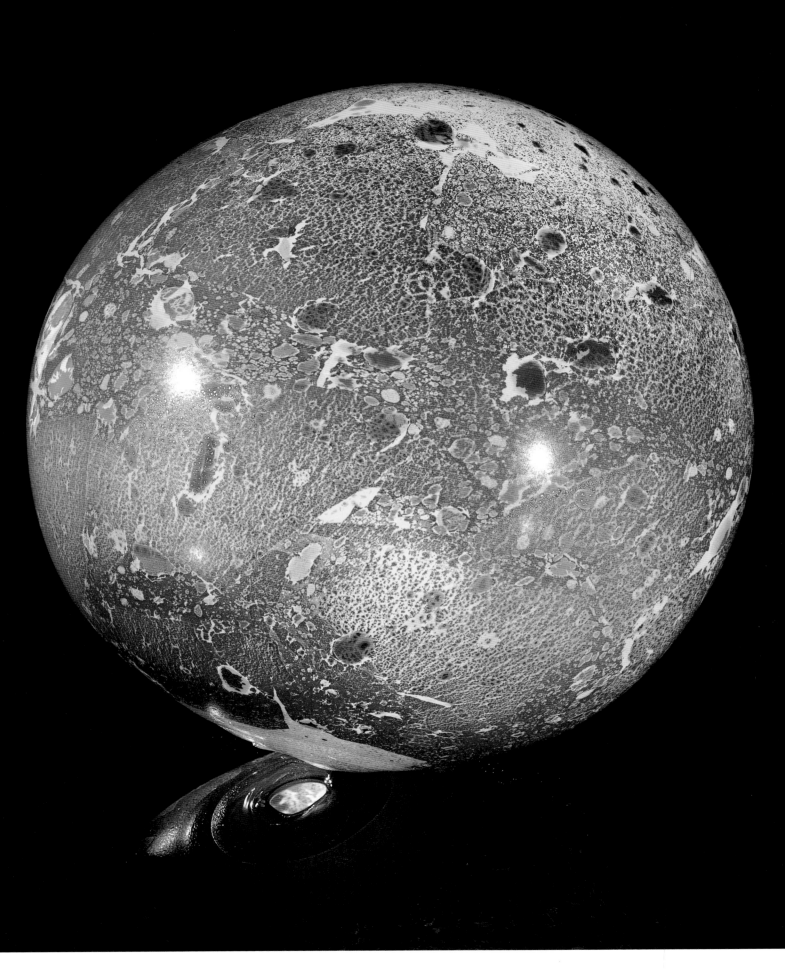

Raw Sienna Niijima Float, 1992, 27 x 28 x 28 inches

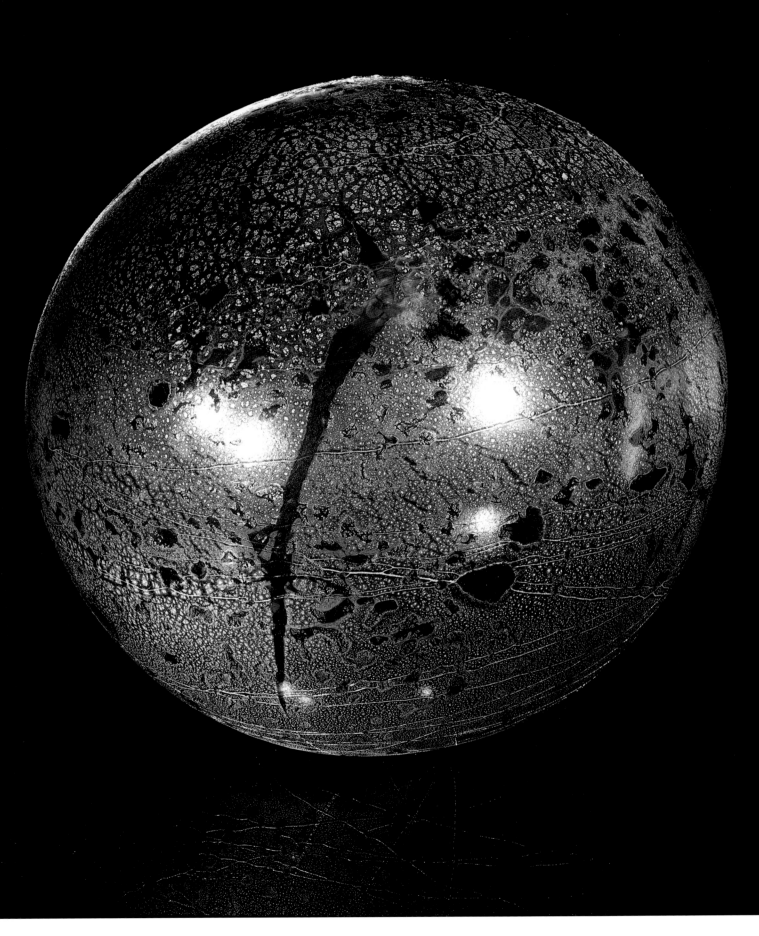

Mottled Silver Niijima Float, 1992, 25 x 26 x 26 inches

Float Drawing, 1992 60 x 40 inches, Acrylic on paper

Float Drawing, 1992, 60 x 40 inches, Acrylic on paper

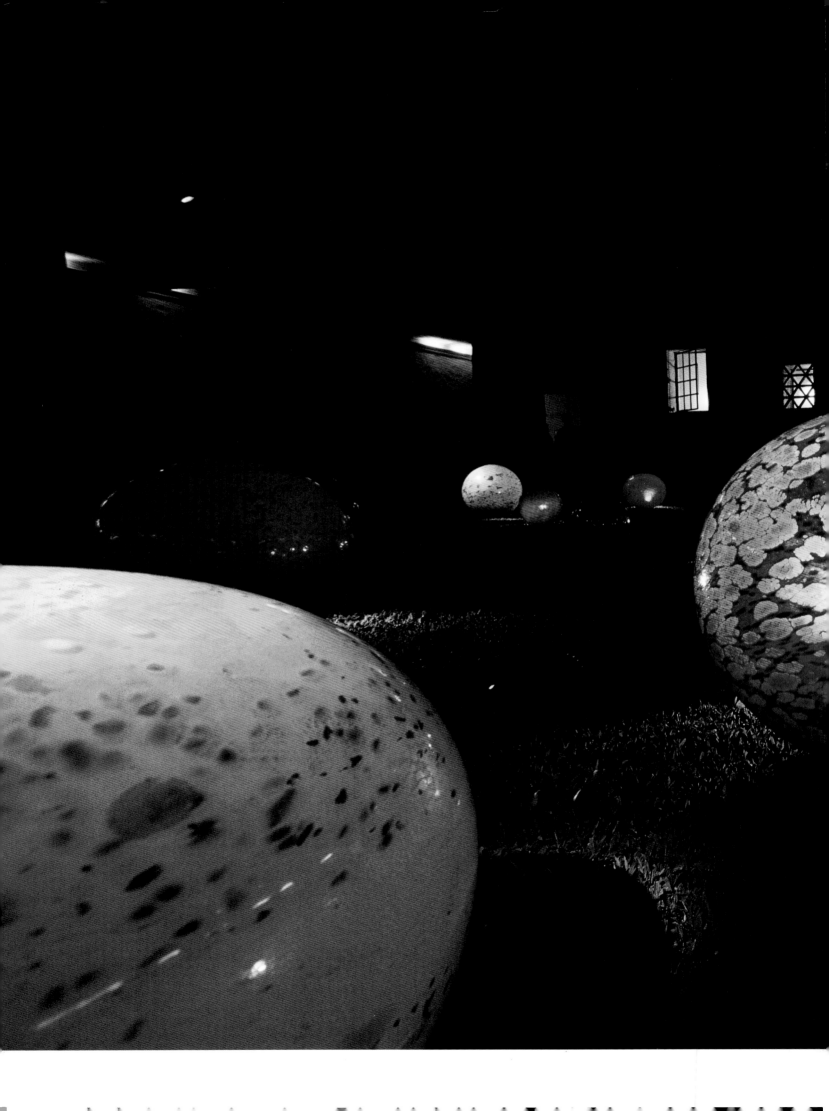

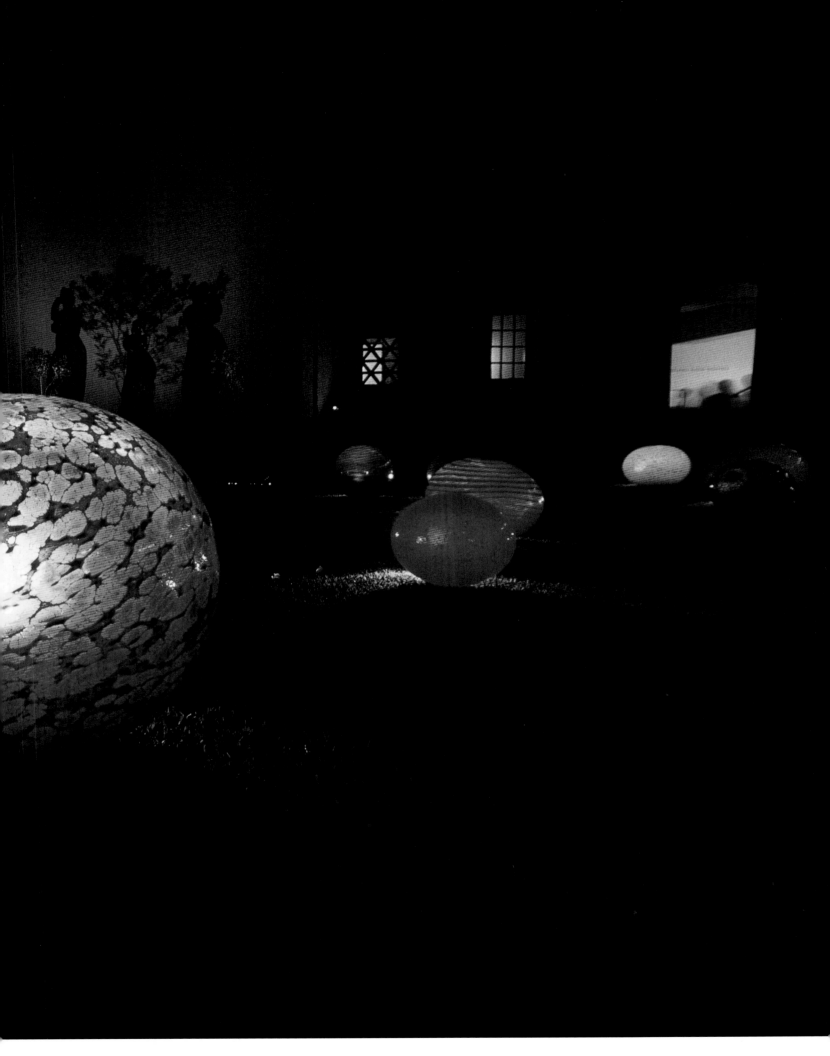

Niijima Floats, "Chihuly Courtyards," Honolulu Academy of Arts, 1992

PILCHUCK STUMPS

Initially I thought my glass would have a major influence on the *Pelléas and Mélisande* Seattle Opera sets, but as it turned out it was just the opposite. While designing the *Forest* set, I discovered an incredible mylar material that looked just like glass. It allowed me to work in a much larger scale — 35 feet tall, gigantic trees. I then thought I would make some glass trees on a smaller scale by blowing the molten glass into molds made out of cedar bark. They looked amazingly like the opera trees, with their iridescent, haunting surfaces of translucent and transparent glass. — *Dale Chihuly, 1992*

The *Pilchuck Stumps,* insofar as they "look" like anything, look like chrysalises abandoned by giant insects or wax molds left over from casting some more finished work of art. It is their very roughness and unfinished look that gives the *Stumps* their interest and power. — *Roger Downey, The Seattle Weekly, 1992*

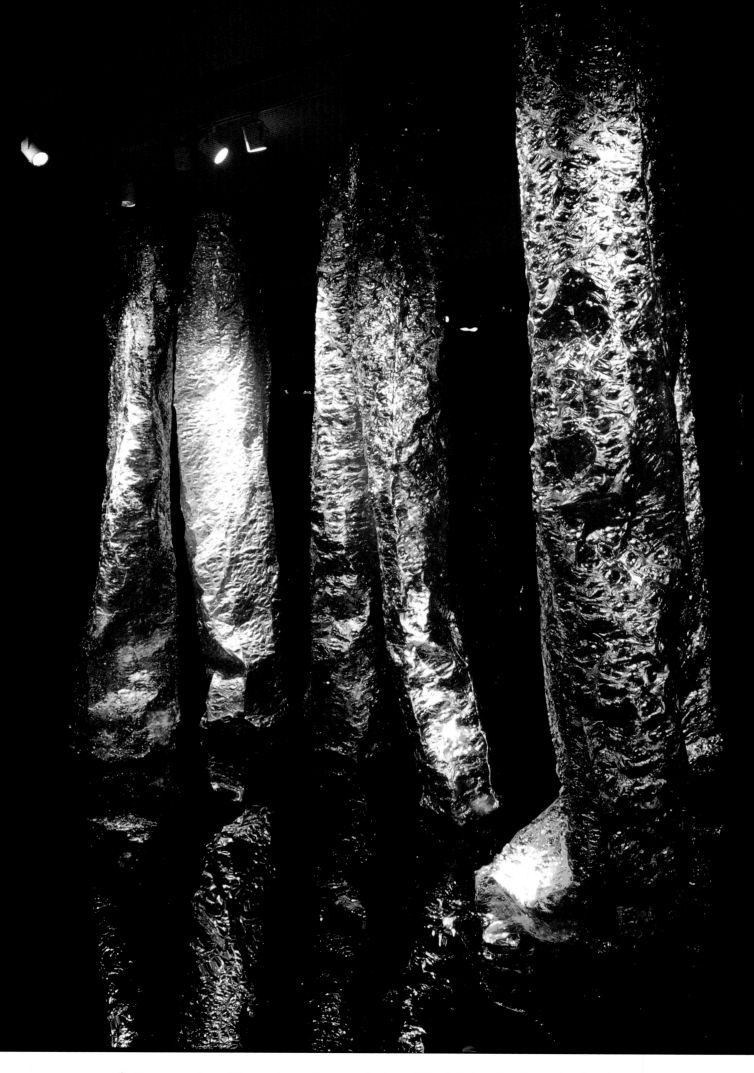

The Forest: Act 1, Scene I (For the Seattle Opera production of Claude Debussy's *Pelléas and Mélisande*), 1992

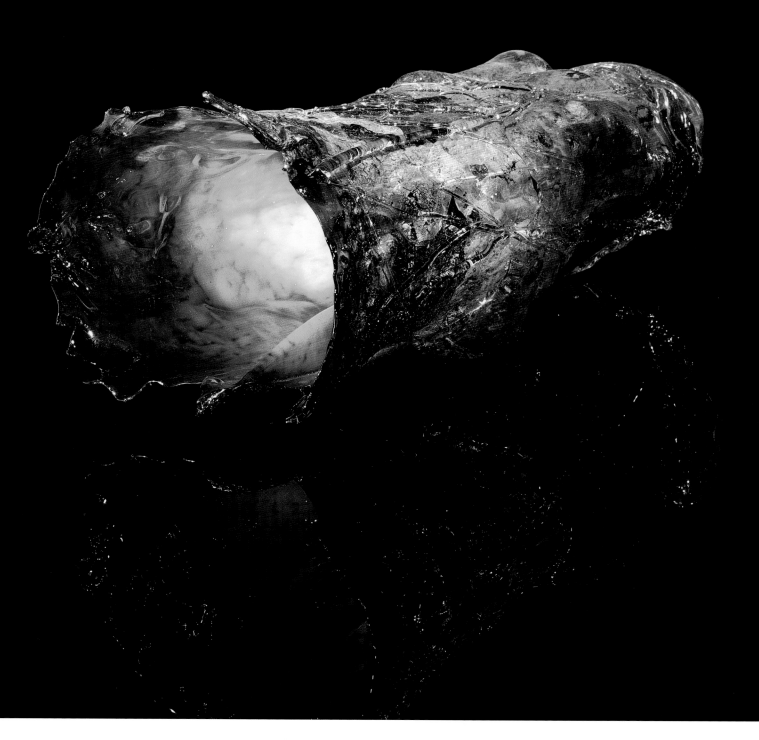

Forest Green and Silver Pilchuck Stump, 1992, 20 x 10 x 9 inches

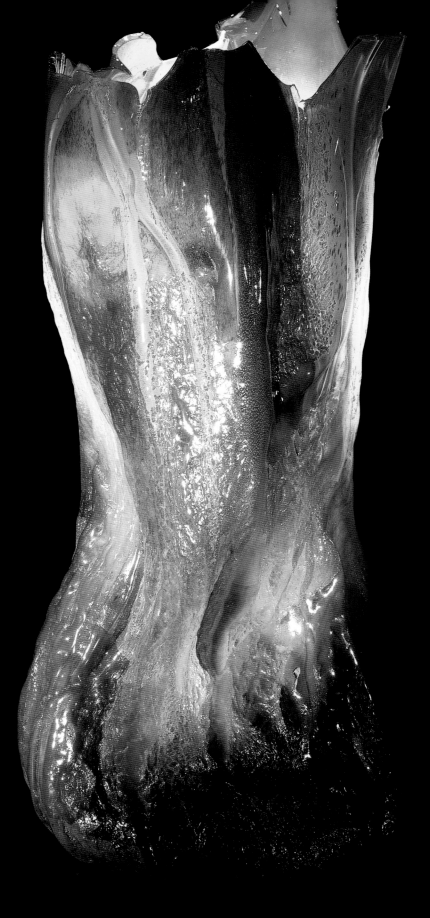

Chartreuse Pilchuck Stump, 1992, 24 x 11 x 11 inches

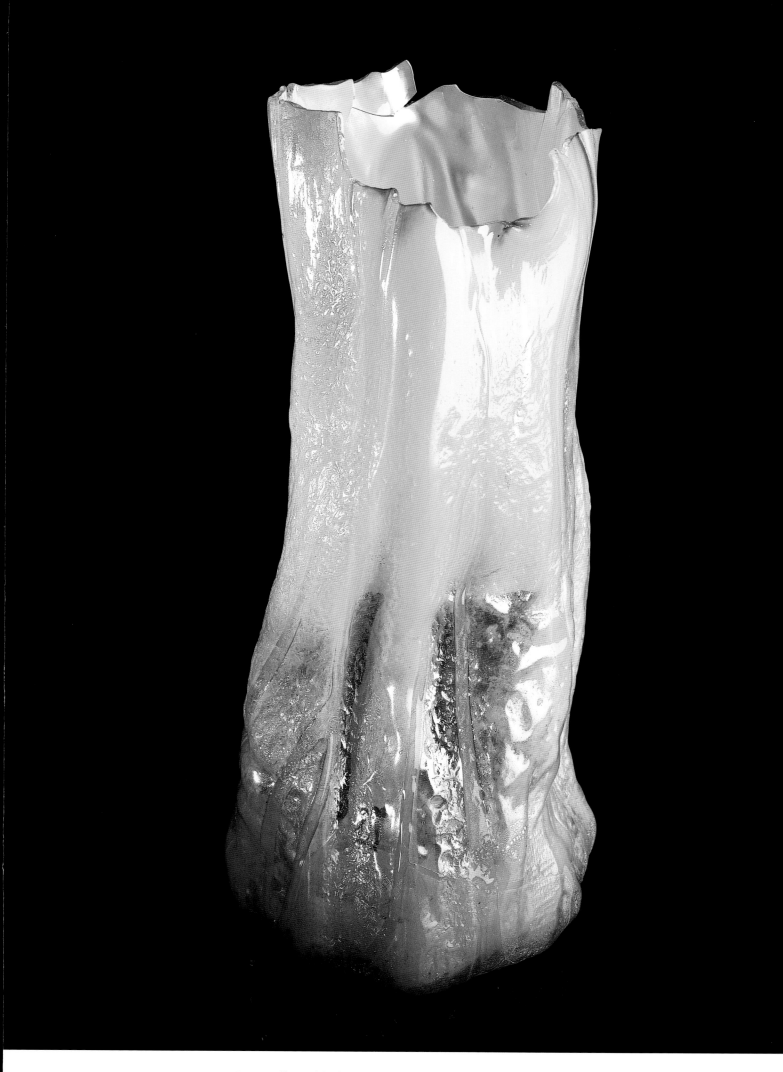

Warm Yellow Pilchuck Stump with Gold Leaf, 1992, 23 x 10 x 10 inches

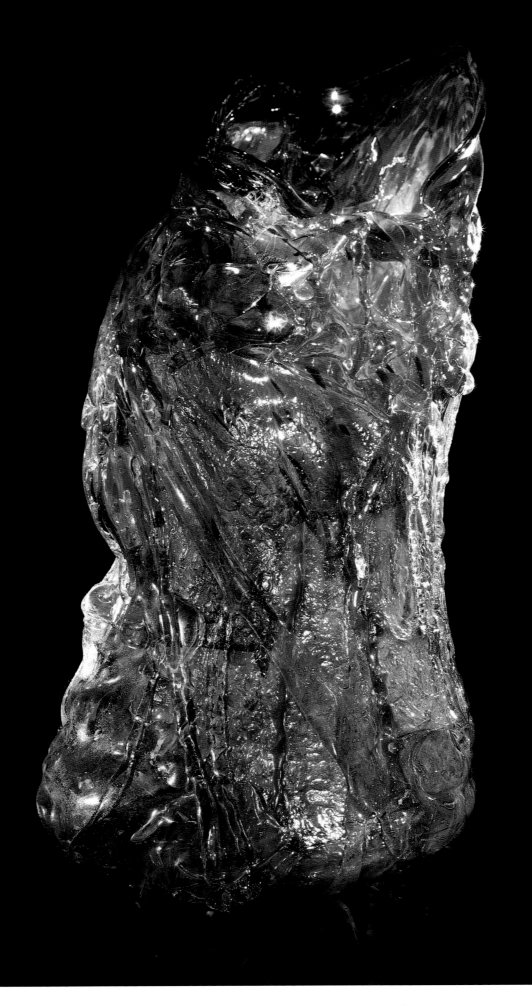

Cobalt and Silver Pilchuck Stump, 1992, 26 x 19 x 17 inches

Pilchuck Stump Drawing, 1992, 60 x 40 inches, Acrylic on paper

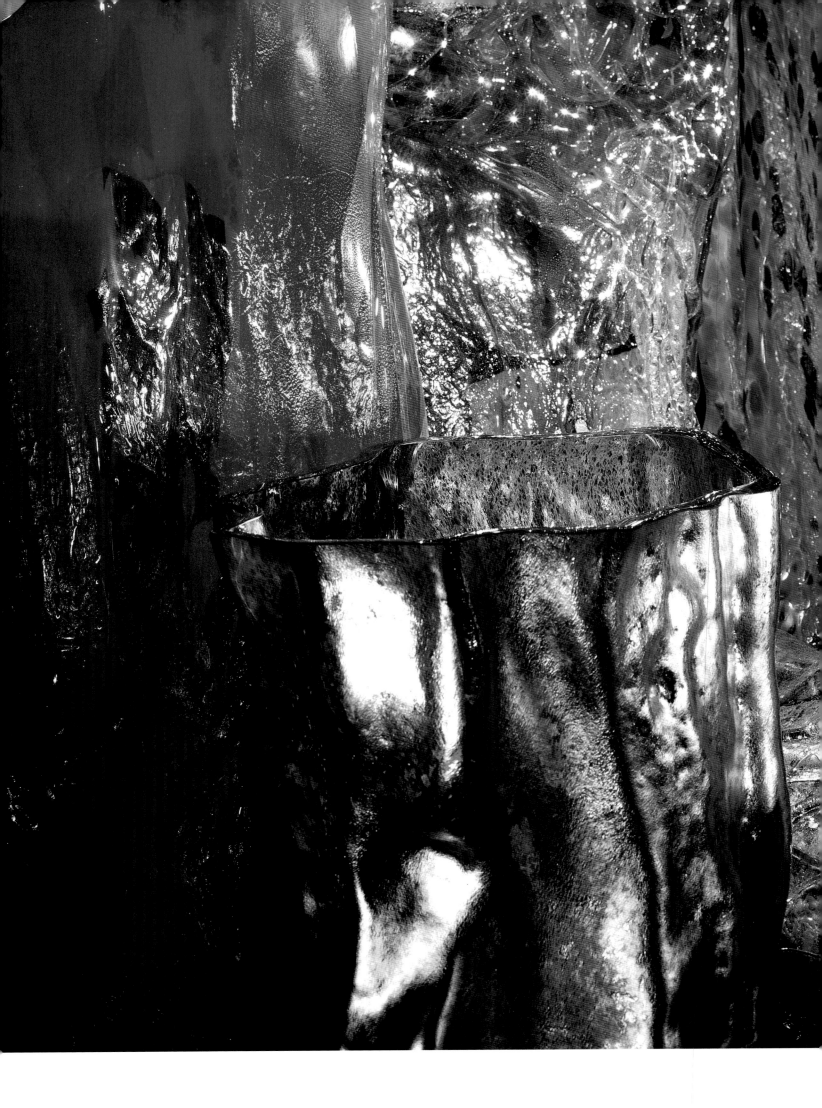

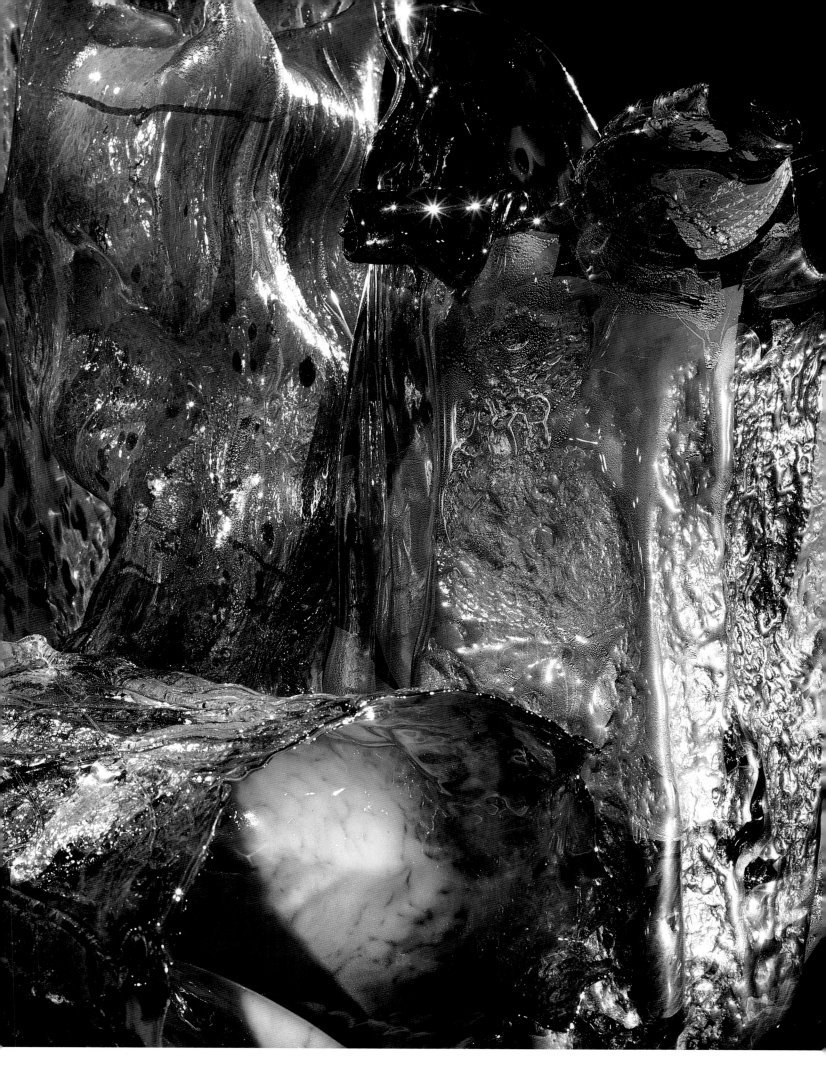

Pilchuck Stumps, The Boathouse, 1991

I would like to thank
all the extraordinary artists and craftspeople
whose teamwork made this possible.

Dale Chihuly

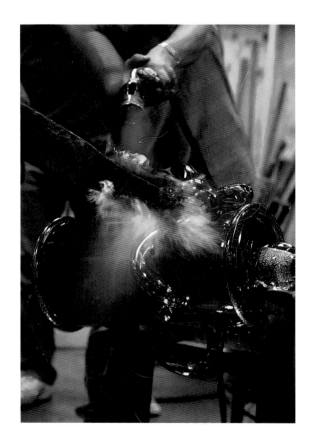

CHRONOLOGY

1941
Born September 20, Tacoma, Washington, to Viola and George Chihuly,
a union organizer.

1956
Older brother, George, killed in Navy Air Force training flight.

1957
Father dies.

1959
Enrolls in University of Puget Sound, Tacoma.

1960
Transfers to University of Washington, Seattle, in Interior Design.

1961–62
Learns to melt and fuse glass in his basement studio in south Seattle.
Becomes rush chairman of Delta Kappa Epsilon fraternity.

1962–63
Travels to Europe and Near East.
In Israel works on a kibbutz.

1963
Re-enters University of Washington, studying interior design and architecture
under Hope Foote and Warren Hill.
In weaving classes with Doris Brockway begins incorporating glass into tapestries.

1964
Returns to Europe, visiting Leningrad and making first of many trips to Ireland.
Receives Seattle Weavers Guild Award.

1965
Meets textile designer Jack Lenor Larsen.
Awarded highest honors from the American Institute of Interior Designers (now the American
Society of Interior Designers).
Receives Bachelor of Arts in Interior Design, University of Washington.
Works as a designer for John Graham Architects, Seattle.
Experimenting on his own, blows glass for the first time.
Encouraged by Russell Day.

1966
Works as commercial fisherman in Alaska earning money for graduate studies in glass.
On a full scholarship, enters University of Wisconsin, Madison, to study glass blowing with
Harvey Littleton.

1967
Receives Master of Science from University of Wisconsin.
Enrolls in Master of Fine Arts program at Rhode Island School of Design (R.I.S.D.).
Teaches glass courses and works on large-scale environmental sculptures incorporating neon,
plastic and other materials.
Meets Italo Scanga.

1968
Receives Master of Fine Arts from R.I.S.D.
Awarded Tiffany Foundation grant for work in glass and Fulbright Fellowship to study glass in Venice.
The first American glass blower to work on the island, begins work at Venini Factory at Murano.
Teaches at Haystack Mountain School of Crafts in Maine for first of four summers.

1969
Continues at Venini.
Makes pilgrimage to Erwin Eisch in Germany as well as Jaroslava Brychtova and Stanislav Libensky
in Czechoslovakia.
Returns to R.I.S.D. in the fall to establish glass department.
Included in "Objects U.S.A.," a traveling exhibition circulated by the Smithsonian Institution,
Washington, D.C.

1970
Meets James Carpenter at R.I.S.D. and begins four-year collaboration.
Included in "Toledo Glass National III," a circulating exhibition organized by the Toledo Museum
of Art, Ohio.

1971
Has solo exhibition with Carpenter at the Museum of Contemporary Crafts.
With a grant from the Union of Independent Colleges of Arts starts Pilchuck Glass School in his home
state of Washington with property donated by arts patrons John Hauberg and
Anne Gould Hauberg.

1972–73
Returns to Venice and blows glass with Carpenter at Venini to prepare for "Glas Heute" exhibition at
the Museum Bellerive, Zurich.
Works on glass architectural projects with Carpenter, including *Leaded Glass Door* for the
Toledo Museum of Art.
Included in traveling show, "American Glass Now," originated by the Corning Museum of Glass,
New York.

1974
Tours European glass centers with Thomas Buechner, director, Corning Museum of Glass.
Experiments on new "glass drawing pick-up techniques" at Pilchuck.
Builds glass studio at Institute of American Indian Art, Santa Fe.

1975
Receives first of two National Endowment for the Arts grants.
Develops *Navajo Blanket Cylinder* series.
Helps start glass program at University of Utah's Snowbird Art School outside Salt Lake City.
Solo exhibition of *Blanket Cylinders* at Utah Museum of Fine Arts, Salt Lake City, and Institute of
American Indian Art, Santa Fe.

1976
Collaborates with Seaver Leslie on *Irish* and *Ulysses Cylinders,* with Flora Mace fabricating
glass drawings.
Travels with Leslie to Great Britain on lecture tour.
Loses sight in left eye in serious automobile accident.
Henry Geldzahler, curator of contemporary art at the Metropolitan Museum of Art, New York,
purchases three *Navajo Blanket Cylinders* for the permanent collection.
Western Association of Art Museums circulates solo exhibition.
Receives an Individual Artist's Grant and, with Kate Elliott, a Master Craftsman
Apprenticeship Grant from the National Endowment for the Arts.

1977
Becomes head of R.I.S.D. sculpture department.
Begins *Pilchuck Basket* series at Pilchuck inspired by seeing Northwest Coast Indian baskets at
Washington State Historical Society, Tacoma.
Exhibits at Seattle Art Museum with Italo Scanga and James Carpenter in show
curated by Charles Cowles.

1978
Exhibition "Baskets and Cylinders: Recent Work by Dale Chihuly" at the Renwick Gallery,
Smithsonian Institution, Washington, D.C.
Meets William Morris, beginning an eight-year working relationship.

1979
Works in Baden, Austria, with Benjamin Moore, William Morris and Michael Scheiner.
Has one-man shows at Lobmeyr, Vienna, and Museu de Arte, São Paulo, Brazil.
Relinquishes gaffer position when shoulder becomes dislocated in body surfing accident.
Included in major traveling exhibition, "New Glass," organized by the Corning Museum of Glass.

1980
Becomes artist-in-residence at R.I.S.D. after resigning as head of Glass Department.
Begins *Sea Forms* series. Individual exhibition at Haaretz Museum, Tel Aviv, Israel.
Executes large-scale, acid-etched, hand-blown stained-glass windows for Shaare Emeth Synagogue in
Saint Louis, with the assistance of Eric Hopkins and Eve Kaplan.

1981
Begins *Macchia* series.
Begins projects in Austria with Benjamin Moore, Rich Royal and Jeff Held.
Has solo exhibitions at Lobmeyr in Vienna and Rosenthal in Berlin.
Returns to work at R.I.S.D.
Travels to Scotland with William Morris and continues on to Orkney Islands.
Spends summer and fall at Pilchuck, preparing for solo show at Tacoma Art Museum.

1982
"Chihuly Glass" exhibition focusing on *Sea Forms* opens at Tacoma Art Museum and travels through
1984 to five American museums.
Works at various glass blowing facilities throughout the country.

1983
Sells "Boathouse" studio in Rhode Island. Moves to Seattle to live and work.

1984
Honored as Rhode Island School of Design's President's Fellow.
Receives Visual Artist's Award from American Council for the Arts and first of three Washington State
Governor's Art Awards.
Returns to cylinder format with *Soft Cylinders* series.
Traveling exhibition, "Chihuly: A Decade of Glass," opens at the Bellevue Art Museum, Washington,
and travels to 13 museums throughout the United States and Canada.

1985
Commissioned to make large architectural installations, including at the Seattle Aquarium as
King County Arts Commission's Honors Award Artist.
Experiments with *Flower Forms.*
Renovates Buffalo Shoe Building as studio in Seattle.

1986
Named Fellow of the American Craft Council.
Receives honorary doctorates from the University of Puget Sound and R.I.S.D. as well as Governor's
Art Award from Rhode Island.

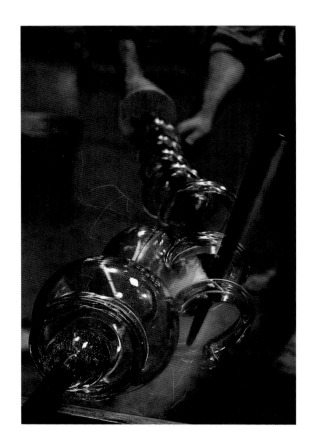

Begins *Persians* series working with gaffer Martin Blank.
Builds first glass blowing studio in Seattle at the Van De Kamp Building.
Survey exhibition "Dale Chihuly: objets de verre," organized by the Musée des Arts Décoratifs, Palais du Louvre, Paris, opens and travels in Europe and the Middle East through 1991.

1987
Completes *Rainbow Frieze* installation at Rockefeller Center, New York.
Honored as University of Washington Alumni Legend.
A retrospective "Chihuly Collection" installed permanently at the Tacoma Art Museum, Washington.

1988
In Seattle begins *Venetians* series with maestro Lino Tagliapietra, inspired by seeing a private collection of Venetian Art Deco vases.
Receives honorary doctorate from California College of Arts and Crafts.

1989
Continues to work with Lino Tagliapietra, Richard Royal, and Benjamin Moore as gaffers on *Venetians* series.
Blows glass in Niijima, Japan; R.I.S.D. and California College of Arts and Crafts.
Special individual exhibition at Bienal de São Paulo travels to Santiago, Chile.
At Pilchuck works with Italian maestro Pino Signoretto, experimenting with additions of *putti* to *Venetians.*
Also, begins to experiment with Lino Tagliapietra adding flower forms to *Venetians* for the *Ikebana* series.

1990
Survey exhibition, "Dale Chihuly: Japan 1990," presented by Azabu Museum of Arts and Crafts, Tokyo.
Renovates Seattle Pocock racing shell factory on Lake Union into new "Boathouse," incorporating glass blowing shop, studio and residence.
Develops *Venetians* further with Lino Tagliapietra and Pino Signoretto in Seattle.

1991
Exhibition "Chihuly: Venetians" organized by the Umeleckoprumyslove Muzeum, Prague, travels in Europe.
Completes major private and public architectural installations, including a Tea Room at the Yasui Konpira-gu Shinto Shrine in Kyoto, Japan, and a wall piece at GTE World Headquarters in Dallas, Texas.
Participates in "Masterpieces" workshop at Pilchuck with Lino Tagliapietra, Richard Marquis and William Warmus.
Begins to experiment with *Niijima Floats* series, working with gaffer Richard Royal.

1992
Exhibits temporary installation of *Niijima Floats* at the American Craft Museum, New York.
Traveling exhibition of *Venetians* continues at major European museums in Germany, The Netherlands and Belgium.
Creates major new architectural installations for traveling retrospective exhibition at the Seattle Art Museum, "Dale Chihuly: Installations 1964–1992."
Also, recreates *20,000 Pounds of Ice* (1971) temporary installation for this show.
Development of chandeliers begins with the *SAM Chandelier.*
Solo exhibitions featuring installations held at the Contemporary Arts Center, Cincinnati; the Honolulu Academy of Arts, Hawaii, and the Taipei Fine Arts Museum, Taiwan.
Executes temporary installation of *Niijima Floats* at the Marco Museum, Monterey, Mexico.
Commissioned for large-scale architectural installations at Little Caesar's Corporate Headquarters in Detroit and Corning Glass Headquarters in Corning, New York.
Develops stage sets for 1993 Seattle Opera production of Claude Debussy's *Pelléas and Mélisande.*
A new glass series, *Pilchuck Stumps,* grows out of these designs.
Receives first National Living Treasure Award given by the United States.

1993
"Chihuly: Form from Fire" begins tour in U.S.A.
"Chihuly in Australia: Glass and Works on Paper" opens at the Powerhouse Museum, Sydney, Australia.

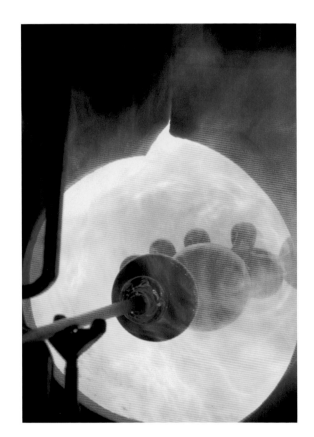

SELECTED MUSEUM COLLECTIONS

Albright-Knox Art Gallery, Buffalo, New York
American Craft Museum, New York, New York
American Glass Museum, Millville, New Jersey
Amon Carter Museum, Fort Worth, Texas
Arkansas Arts Center, Little Rock, Arkansas
Art Gallery of Greater Victoria, Victoria, British Columbia
Art Museum, Arizona State University, Tempe, Arizona
Australian National Gallery, Canberra, Australia
Azabu Art and Crafts Museum of Tokyo, Tokyo, Japan
Boca Raton Museum of Art, Boca Raton, Florida
Boston Museum of Fine Arts, Boston, Massachusetts
Carnegie Museum of Art, Pittsburgh, Pennsylvania
Chrysler Museum at Norfolk, Norfolk, Virginia
Cleveland Art Museum, Cleveland, Ohio
Contemporary Arts Center of Hawaii, Honolulu, Hawaii
Cooper-Hewitt Museum, National Museum of Design, The Smithsonian Institution,
New York, New York
Corning Museum of Glass, Corning, New York
Crocker Art Museum, Sacramento, California
Currier Gallery of Art, Manchester, New Hampshire
Dallas Museum of Fine Arts, Dallas, Texas
De Cordova and Dana Museum and Park, Lincoln, Massachusetts
Denver Art Museum, Denver, Colorado
The Detroit Institute of Arts, Detroit, Michigan
Elvehjem Museum of Art, University of Wisconsin, Madison, Wisconsin
Everson Museum of Art, Syracuse, New York
Fine Arts Museum of the South, Mobile, Alabama
Galerie d'Art Contemporain, Nice, France
Glasmuseum Ebeltoft, Ebeltoft, Denmark
Glasmuseum Frauenau, Frauenau, Germany
Glasmuseum Wertheim, Wertheim, Germany
Grand Rapids Museum, Grand Rapids, Michigan
Haaretz Museum, Tel Aviv, Israel
High Museum of Art, Atlanta, Georgia
Hokkaido Museum of Modern Art, Hokkaido, Japan
Honolulu Academy of Art, Honolulu, Hawaii
Hunter Museum of Art, Chattanooga, Tennessee
Indianapolis Museum of Art, Indianapolis, Indiana
Israel Museum, Jerusalem, Israel
J.B. Speed Art Museum, Louisville, Kentucky
Japan Institute of Arts and Crafts, Tokyo, Japan
Jesse Besser Museum, Alpena, Michigan
Kestner Museum, Hannover, Germany
Krannert Art Museum, University of Illinois, Champaign, Illinois
Kunstammlungen der Veste Coburg, Coburg, Germany
Kunstindustrimuseum Kopenhagen, Copenhagen, Denmark
Kunstmuseum, Düsseldorf, Germany
Kyoto Museum, Kyoto, Japan
Leigh Yawkey Woodson Art Museum, Wausau, Wisconsin
Lobmeyr Museum, Vienna, Austria
Los Angeles County Museum of Art, Los Angeles, California

Lowe Art Museum, Coral Gables, Florida
Lyman Allyn Art Museum, New London, Connecticut
Madison Art Center, Madison, Wisconsin
Metropolitan Museum of Art, New York, New York
Milwaukee Art Museum, Milwaukee, Wisconsin
Morris Museum, Morristown, New Jersey
Musée des Arts Décoratifs, Palais du Louvre, Paris, France
Musée des Arts Décoratifs, Lausanne, Switzerland
Musée des Beaux Arts et de la Céramique, Rouen, France
Museum Bellerive, Zurich, Switzerland
Museum Boymans-Van Beuningen, Rotterdam, The Netherlands
Museum für Kunst und Gewerbe, Hamburg, West Germany
Museum für Kunsthandwerk, Frankfurt, Germany
Museum of Art, Fort Lauderdale, Florida
Museum of Art, Rhode Island School of Design, Providence, Rhode Island
Museum of Modern Art, New York, New York
Museum of Contemporary Art, Chicago, Illinois
Muskegon Museum of Art, Muskegon, Michigan
Muzeum Mesta Brna, Brno, Czechoslovakia
Muzeum Skla A Bizuterie, Jablonec nad Nisou, Czechoslovakia
National Museum, Stockholm, Sweden
National Museum of American Art, Smithsonian Institution, Washington, D.C.
National Museum of American History, Smithsonian Institution, Washington, D.C.
National Museum of Modern Art, Kyoto, Japan
New Orleans Museum of Art, New Orleans, Louisiana
Newport Harbor Art Museum, Newport Beach, California
Palm Beach Community College Art Museum, Lake Worth, Florida
Parrish Museum of Art, Southampton, New York
Philadelphia Museum of Art, Philadelphia, Pennsylvania
Phoenix Art Museum, Phoenix, Arizona
Portland Art Museum, Portland, Oregon
Princeton University Art Museum, Princeton, New Jersey
Provincial Musée Sterckshof, Antwerpen, Belgium
Queensland Art Gallery, Brisbane, Australia
Royal Ontario Museum, Toronto, Canada
Saint Louis Art Museum, Saint Louis, Missouri
San Francisco Museum of Modern Art, San Francisco, California
Seattle Art Museum, Seattle, Washington
Shimonoseki City Art Museum, Shimonoseki, Japan
Smith College Museum of Art, Northampton, Massachusetts
Spencer Museum of Art, University of Kansas, Lawrence, Kansas
Suomenlasimuseo, Riihimaki, Finland
Tacoma Art Museum, Tacoma, Washington
Toledo Museum of Art, Toledo, Ohio
Umeleckoprumsylove Muzeum, Prague, Czechoslovakia
University Art Museum, University of California, Berkeley, California
University of Michigan, Dearborn, Michigan
Utah Museum of Fine Arts, Salt Lake City, Utah
Victoria and Albert Museum, London, England
Wadsworth Atheneum, Hartford, Connecticut
Walker Hill Art Center, Seoul, Korea
Whatcom Museum of History and Art, Bellingham, Washington
Whitney Museum of American Art, New York, New York
Yale University Art Gallery, New Haven, Connecticut
Yokohama Museum, Yokohama, Japan

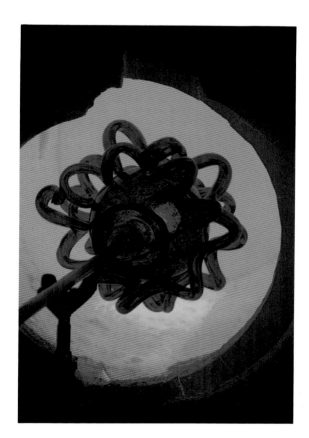

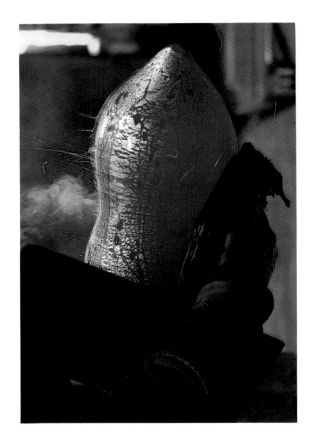

PUBLIC COLLECTIONS

American Embassy, London, England
American Embassy, Paris, France
Australian Arts Council, Sydney, Australia
Bass Brothers Enterprises, Fort Worth, Texas
California College of Arts and Crafts, Oakland, California
Chase Manhattan Bank, New York, New York
Columbia Tower Club, Seattle, Washington
Corning World Headquarters, Corning, New York
Davis, Wright, Tremaine, Seattle, Washington
Foster & Marshall, Inc., Spokane, Washington
Frances and Sydney Lewis Foundation, Richmond, Virginia
Genesee Partners, Bellevue, Washington
Harold Hess Company, Inc., Philadelphia, Pennsylvania
The Hearn Company, Chicago, Illinois
IBM Corporation, New York, New York
Johnson Wax Collection, Racine, Wisconsin
Little Caesar's, Detroit, Michigan
MCI, Washington, D.C.
Microsoft Corporation, Redmond, Washington
National Geographic Society, Washington, D.C.
Niijima Glass Art Center, Niijima, Japan
Paccar, Inc., Bellevue, Washington
Pacific Enterprises, Los Angeles, California
Pilchuck Glass School, Stanwood, Washington
The Prudential Insurance Company of America, Newark, New Jersey
Robins, Kaplan, Miller and Ciresi, Minneapolis, Minnesota
Safeco Insurance Companies, Seattle, Washington
Seaman's Bank, New York, New York
Seattle First National Bank, Seattle, Washington
Security Pacific Bank, Los Angeles, California
Simpson Investment Company, Seattle, Washington
Simpson Paper Company, San Francisco, California
Stone Container Corporation, Chicago, Illinois
Swedish Hospital, Seattle, Washington
University of Puget Sound, Tacoma, Washington
U.S. News & World Report, Washington, D.C.
Washington University Medical School, Saint Louis, Missouri
Weyerhaeuser, Tacoma, Washington

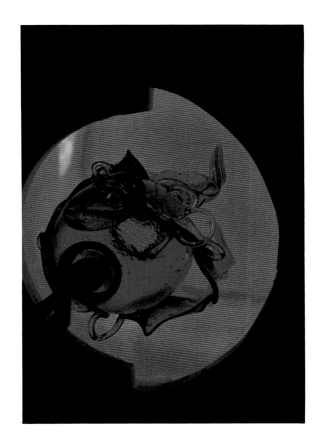

SELECTED PERMANENT
INSTALLATIONS 1964–1992

1992
Malina Window, Little Caesar's Corporate Headquarters, Detroit, Michigan
Ikebana Installation, Collection of Mr. and Mrs. Stuart Cauff, Miami, Florida
Persian Pair Installation, Japan-America Society, UNICO Properties, Inc., Seattle, Washington
Brassner Wall, Collection of Mr. and Mrs. Jules Brassner, West Palm Beach, Florida

1991
GTE Wall, GTE World Headquarters, Dallas, Texas
Hiroyoshi Torii Tea Room, Yasui Konpira-gu Shinto Shrine, Kyoto, Japan
Violet and Burgundy Wall Piece, Collection of Mr. and Mrs. Leon Berlin, Montreal, Quebec, Canada
Shulman Wall, Collection of Mr. and Mrs. Lawrence Shulman, Chicago, Illinois

1990
Blue and Oxblood Wall Installation, Robins, Kaplan, Miller and Ciresi, Minneapolis, Minnesota
Dobbs Wall, Collection of Mr. Leonard Dobbs, Sands Point, New York
Milstein Wall, Collection of Mr. and Mrs. Paul Milstein, New York, New York
Security Pacific Bank Installation, Los Angeles, California
Tropicana Wall, Tropicana Products, Inc., Bradenton, Florida

1989–91
Pacific First Persian Installation, Prescott Collection of Pilchuck Glass, Pacific First Centre,
Seattle, Washington

1989
Oceanic Grace Installation, S.S. Oceanic Grace, Tokyo, Japan
Persian Installation, Collection of Irvin J. Borowsky and Laurie Wagman, Philadelphia, Pennsylvania
Radnor Stairwell, Collection of Norman and Suzanne Cohn, Radnor, Pennsylvania

1988
Adelaide Fountain, Hyatt Hotel, Adelaide, Australia
Chancellor Park Persian Installation, Chancellor Park, San Diego, California
Frank Russell Installation, Frank Russell Building, Tacoma, Washington
Shirley Wall Installation, Collection of Jon and Mary Shirley, Bellevue, Washington

1987
Puget Sound Forms, The Seattle Aquarium, Seattle, Washington
Rainbow Room Frieze, Rockefeller Center, New York, New York

1986
Flower Forms #2, Sheraton Seattle Hotel and Towers, Seattle, Washington

1985
Fleet Bank Installation, Fleet National Bank, Providence, Rhode Island
Macchia Installation, Hillhaven Corporation, Tacoma, Washington

1984
Madison Hotel Sea Form Set, Stouffer Madison Hotel, Seattle, Washington
Tacoma Financial Center Installation, Tacoma, Washington

1983
Wintergarden Installation, Sheraton Tacoma Hotel, Tacoma, Washington

1980
Shaare Emeth Synagogue Windows, Saint Louis, Missouri

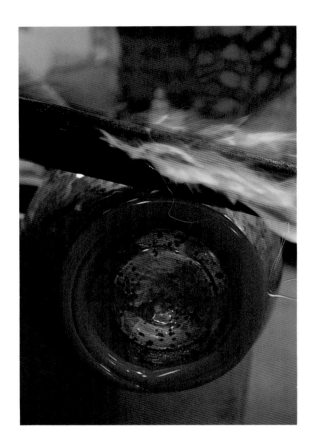

1979
Pilchuck Basket Installation, U.S. Border Station, Blaine, Washington

1978
Bluepoint Doors, Bluepoint Oyster Bar & Restaurant, Providence, Rhode Island

1974
Corning Glass Wall, Corning Museum of Glass, Corning, New York
(in collaboration with James Carpenter)
Pfannebecker Window, Collection of Robert J. Pfannebecker, Lancaster, Pennsylvania (in
collaboration with James Carpenter)

1973
Pilchuck Window Sampler No. 3, Crafts Council of Australia, Sydney, Australia
(in collaboration with James Carpenter)
Cast Glass Door, Collection of John H. Hauberg, Seattle, Washington (in collaboration with
James Carpenter)

1971–72
Glass Forest #2, Museum Bellerive, Zurich, Switzerland
(in collaboration with James Carpenter)

1964
Weaving with Fused Glass, Collection of Viola Chihuly, Tacoma, Washington

SELECTED BIBLIOGRAPHY

By the artist

"Introduction," in *Clearly Art: Pilchuck's Glass Legacy.* Bellingham, Washington: Whatcom Museum of History and Art, 1992. Essay by Lloyd J. Herman.

"Dale Chihuly," in Bonnie J. Miller. *Out of the Fire: Contemporary Glass Artists and Their Work.* San Francisco: Chronicle Books, 1991: 30–33.

"Dale Chihuly." *Glass Art Society Journal* (1990): 36–40.

Essay in *Venetians: Dale Chihuly.* Altadena, California: Twin Palms Publishers, 1989. Introduction by Ron Glowen.

"On the Road," in *Chihuly: Color, Glass and Form.* Tokyo, New York, and San Francisco: Kodansha International, Ltd., 1986. Foreword by Henry Geldzahler.

Statement in *Pilchuck: The Creative Fire.* Pilchuck Faculty Exhibition. Washington State Capitol Museum, 1986. Essay by Karen S. Chambers.

"Cylinders," "Baskets," Sea Forms," "Macchia," in *Chihuly: A Decade of Glass.* Bellevue, Washington: Bellevue Art Museum, 1984. Essays by Jack Cowart and Karen S. Chambers.

Interviews with the artist

Diamonstein, Barbaralee. *Handmade in America: Conversations with Fourteen Craftmasters.* New York: Harry N. Abrams, Inc., 1983.

Leslie, Seaver W. "Glass in Architecture: An Interview with Dale Chihuly and James Carpenter." *Glass Art Magazine* 3, 4 (August 1978) : 26–33. First publ. in *Bulletin of Rhode Island School of Design Alumni Edition* 61, 4 (March 1975): 15–22.

Matano, Koji, ed. "Dale Chihuly Interview." *Glasswork* (May 1990): 2–11.

Save, Colette, ed. "Dale [Chihuly], boss du verre." *l'Atelier des métiers d'art* 114 (December 1986–January 1987): 35–37 (trans. French).

Sinz, Dagmar. "A Talk with Dale Chihuly: To Breathe a Form into Glass." *Neues Glas* 2 (January/March 1987): 14–19.

Catalogues and monographs on the artist

Chambers, Karen S. "Dale Chihuly, All American," in *Dale Chihuly/Klaus Moje.* Denmark: Glasmuseum Ebeltoft, 1991. Introduction by Finn Lynggaard.

Cowart, Jack, and Karen S. Chambers. *Chihuly: A Decade of Glass.* Bellevue, Washington: Bellevue Art Museum, 1984.

Dale Chihuly: Tutti Putti. Santa Monica, California: Pence Gallery, 1991.

Dale Chihuly: Venetians. Washington, D.C.: Maurine Littleton Gallery, 1989.

Dale Chihuly: Soft Cylinders. Washington, D.C.: Maurine Littleton Gallery, 1987.

Geldzahler, Henry. *Dale Chihuly: Japan 1990.* Tokyo: Japan Institute of Arts and Crafts, 1990.

——— , foreword. *Chihuly/Persians.* Bridgehampton, New York: Dia Art Foundation, 1988. Essay by Robert Hobbs.

——— , foreword. *Chihuly: Color, Glass and Form.* Tokyo, New York and San Francisco: Kodansha International Ltd., 1986. Essays by Karen S. Chambers, Dale Chihuly, and Michael W. Monroe.

Geldzahler, Henry and Robert Hobbs. *Dale Chihuly: objets de verre.* Paris: Musée des Arts Décoratifs, 1986.

Glowen, Ron. *Venetians: Dale Chihuly.* Altadena, California: Twin Palms Publishers, 1989. Essay by Dale Chihuly.

Kangas, Matthew. "Chihuly: Gifts from the Sea." *Dale Chihuly: Niijima Floats.* New York: American Craft Museum, 1992.

Monroe, Michael W. *Baskets and Cylinders: Recent Glass by Dale Chihuly.* Washington, D.C.: Renwick Gallery of the National Collection of Fine Arts, 1978.

Norden, Linda. *Chihuly Glass.* Pawtuxet Cove, Rhode Island: Dale Chihuly, 1982.

Sims, Patterson. *Dale Chihuly: Installations 1964–1992.* Seattle, Washington: Seattle Art Museum, 1992.

Books including the artist

Charleston, Robert J. *Masterpieces of Glass: A World History from the Corning Museum of Glass.* Expanded ed. New York: Harry N. Abrams, Inc., 1990.

Frantz, Susanne K. *Contemporary Glass: A World Survey from the Corning Museum of Glass.* New York: Harry N. Abrams, Inc., 1989.

Geldzahler, Henry, Patterson Sims, and Narcissus Quagliata. *William Morris Glass: Artifact and Art.* Seattle and London: University of Washington Press, 1989.

Hampson, Ferdinand C., ed. *Glass: State of the Art 1984.* Detroit and Huntington Woods, Michigan: Habatat Galleries, Ella Sharp Museum and Elliot Johnston Publishers, 1985. Introduction by Marsha Miro.

Klein, Dan. *Glass: A Contemporary Art.* New York: Rizzoli International Publications, 1989.

Klein, Dan, and Ward Lloyd, eds. *The History of Glass.* London: Orbis, 1984.

Miller, Bonnie J. *Out of the Fire: Northwest Glass Artists and Their Work.* San Francisco: Chronicle Books, 1991.

Zerwick, Chloe. *A Short History of Glass.* New York: Harry N. Abrams, Inc., 1990.

Exhibition catalogs including the artist

Aronson, Margery. *The Prescott Collection of Pilchuck Glass at Pacific First Centre. . . .* Seattle: Prescott, 1990.

——— . "Dale Chihuly: Flower Form 2." *Sheraton Seattle Hotel & Towers Collection Guide.* Seattle: Sheraton Hotel, 1990.

Billeter, Erika. *Glas Heute: Kunst oder Handwerk?* Zurich: Museum Bellerive, 1972.

Broos, Kees, ed. *Beelden in Glas* (Glass Sculpture). Utrecht: Stichting Glas, Veen–Reflex, 1986.

Buechner, Thomas S. *Glass America, 1978.* New York: Contemporary Art Glass Group and the Glass Art Society, 1978.

Buechner, Thomas S., Takako Sano, and Tsuneo Yoshimizu. *American Glass Now III.* Tokyo: Nippon Gakki Company, 1976.

——— , preface. *New Glass: A Worldwide Survey.* New York: The Corning Museum of Glass, 1979. "Overview" by William Warmus.

Buechner, Thomas S., et al. *World Glass Now '82*. Sapporo, Japan: Hokkaido Museum of Modern Art, 1982.

Burke, Margaret R. *Art in Craft Media: The Haystack Tradition*. Brunswick, Maine: Bowdoin College Museum of Art, 1981.

Chambers, Karen S. *Pilchuck: The Creative Fire*. Pilchuck Faculty Exhibition. Olympia: Washington State Capitol Museum, 1986. Statement by Dale Chihuly.

Cowles, Charles. *Carpenter, Chihuly, Scanga 1977*. Seattle: Seattle Art Museum, 1977.

Dale Chihuly/James Carpenter. New York: Museum of Contemporary Crafts, 1971.

Failing, Patricia, introduction. *Chihuly: Works on Paper*. Tacoma, Washington: Tacoma Art Museum, 1991.

Filler, Martin. "The Interior Landscape and the Politics of Change: 1960–1975," in *High Styles: Twentieth Century American Design*. New York: The Whitney Museum of American Art with Summit Books, 1986. Introduction by Lisa Phillips.

Geldzahler, Henry. "Dale Chihuly." *20a Bienal Internacional de São Paulo*. São Paulo, Brazil: Fundacão Bienal de São Paulo, 1989.

Contemporary Studio Glass: An International Collection. National Museums of Modern Art, Tokyo and Kyoto, 1980/81. New York and Tokyo: John Weatherhill of New York and Tokyo 1982, (Japanese ed. c. 1981, Kyoto: Tankosha, 1981).

The Haggerty Museum of Art. *Twentieth Century Masters of American Glass*. Milwaukee, Wisconsin: The Haggerty Museum of Art, Marquette University, 1991.

Harrington, LaMar, foreword. *Pilchuck School: The Great Northwest Glass Experiment* Bellevue, Washington: Bellevue Art Museum, 1988.

Herman, Lloyd J. *Clearly Art: Pilchuck's Glass Legacy*. Bellingham, Washington: Whatcom Museum of History and Art, 1992.

Hunter-Stiebel, Penelope. "The Studio Glass Movement," in *American Glass Art: Evolution and Revolution*. Convent, New Jersey: Morris Museum of Arts and Sciences, 1982.

Johns, Barbara. *Modern Art from the Pacific Northwest in the Collection of the Seattle Art Museum*. Seattle, Washington: Seattle Art Museum, 1990.

Kessler, Jan. *Luminous Impressions: Prints from Glass Plates*. Charlotte, North Carolina: Mint Museum, 1987.

Lang, Sherry. *Glass Routes*. Lincoln, Massachusetts: DeCordova Museum, 1981.

Lippuner, Rosmarie. *Expressions en verre II*. Lausanne: Musée des Arts Décoratifs, 1989.

Lynggaard, Finn. *Moderne International Glaskunst Ebeltoft*. Ebeltoft, Denmark: Glasmuseum Ebeltoft, 1984.

——— . "Studio Glass — A Brief History," in *Glasmuseum*. Ebeltoft, Denmark: Glasmuseum Ebeltoft, 1992.

Manhart, Marcia, and Tom Manhart, eds. *The Eloquent Object: The Evolution of American Art in Craft Media since 1945*. Tulsa, Oklahoma: The Philbrook Museum of Art, 1987 (Japanese ed., 1989).

Metropulos, Linda. *Six Artists: Two and Three Dimensions*. Pittsburgh, Pennsylvania: The Society for Art in Crafts, 1987.

Michael, Erika. *The Frozen Moment: Contemporary Northwest Images in Glass*. Bellevue, Washington: Bellevue Art Museum, 1991.

Nordness, Lee. *Objects: U.S.A.* New York: Viking Press, 1970.

Ohm, Annaliese, introduction. *Modernes Glas aus Amerika, Europa und Japan.* Frankfurt am Main: Museum für Kunsthandwerk, 1976.

Palladino-Craig, Allys. *A Generation in Glass Sculpture.* Tallahassee: Florida State University Fine Arts Gallery and Museum, 1988.

Phillips, Robert F., and Paul J. Smith. *American Glass Now.* Toledo, Ohio: Toledo Museum of Art, 1972. Introduction by Otto Wittman.

Sano, Takako, and Itoko Iwata. *Glass Now '84.* Tokyo: Nippon Gakki Co., 1984.

Slivka, Rose. *Four Leaders in Glass.* Los Angeles: Craft and Folk Art Museum, 1980.

Smith, Paul J. *Craft Today U.S.A.* New York: American Craft Museum, 1989 (based in part on *Craft Today: Poetry of the Physical,* American Craft Museum, 1986).

Smith, Paul J., and Edward Lucie-Smith. *Craft Today: Poetry of the Physical.* New York: American Craft Museum and Weidenfeld and Nicolson, 1986.

Warmus, William. *The Venetians: Modern Glass 1919–1990.* New York: Muriel Karasik Gallery, 1990.

——— . "Between Two Worlds," *Contemporary Glass Sculpture: Innovative Form and Expression.* Summit, New Jersey: New Jersey Center for Visual Arts, 1992.

World Glass Now '91. Sapporo, Japan: Hokkaido Museum of Modern Art, 1991.

Periodical articles about the artist

Anderson, Alexandra. "Creativity in Glass." *Dialogue* 60 (February 1983): 49–55.

— . "Bravura Glass." *Portfolio* 4, 4 (July/August 1982): 84–85, 87.

Baro, Gene. "New York Letter: Dale Chihuly." *Art International* 24, 9–10 (August/September 1981): 125–126.

Bourdon, David. "Chihuly: Climbing the Wall." *Art in America* 78, 6 (June 1990): 164–167.

Brunsman, Laura. "Dale Chihuly: Seattle Art Museum." *Glass Magazine* 49 (Fall): 48–49.

Chambers, Karen S. "The Man Who Made Glassblowing [sic] a Fine Art: Washington's Dale Chihuly and the Glass Movement." *The World & I* 2, 11 (November 1987): 246–250.

——— . "Chihuly on the Road." *New Work* (Winter/Spring 1986): 37.

——— . "Mission: Impossible." *New Work* 13/14 (Winter/Spring 1983): 30–36. Reprinted with editorial changes in *Chihuly: A Decade of Glass* and *Glass: State of the Art.*

DiNoto, Andrea. "New Masters of Glass." *Connoisseur* 211, 846 (August 1982): 22–24.

Hall, Lee. "Baskets and Cylinders: Dale Chihuly." *Craft Horizons* 39, 2 (March/April 1979): 24–29.

Hoving, Thomas, Matthew Gurewitsch and Priscilla Eakeley. "American Living Monuments: A Celebration of One Hundred Thirty-One Superachievers." *Connoisseur* 214, 869 (July 1984): 96–101, 113.

Hunter-Stiebel, Penelope. "Contemporary Art Glass: An Old Medium Gets a New Look." *ARTNews* 80, 6 (June 1981): 130–135.

Kangas, Matthew. "Dale Chihuly: A Return to Origins." *Glass Magazine* 39 (1990): 18–27.

Krakauer, Jon. "Dale Chihuly Has Turned Art Glass into a Red-Hot Item." *Smithsonian* 22, 11 (February 1992): 90–101.

Luini, Micaela Martegani. "Dale Chihuly." *Juliet Art Magazine* 54 (October 1991): 33.

Manzella, David. "Dale Chihuly: The Fluid Breath of Glass." *Craft Horizons* 31, 6 (December 1971): 22–25.

Moorman, Peggy. "Dale Chihuly: Charles Cowles [Gallery Exhibit]." *ARTNews* 83, 3 (March 1984): 212.

Mueller, Megan. "Dale Chihuly: American Craft Museum, Charles Cowles." *ARTNews* 91, 5 (May 1992): 125–126.

Norden, Linda. "Dale Chihuly: Shell Forms." *Arts Magazine* 55, 6 (June 1981): 150–151.

Parry, Elsa S. "Dale Chihuly: Teamwork and Spontaneity." *American Art Glass Quarterly* 3, 1 (1985): 42–55.

Perreault, John. "Dale Chihuly: Charles Cowles Gallery." *Art Express* (September/October 1981): 61.

Ricke, Helmut. "World Glass Now '91." *Neues Glas* 3 (March 1991): 20–25.

Scremini, Clara. "Dale Chihuly." *La Revue de la céramique et du verre* 31 (November–December 1986): 38–41.

Slivka, Rose. "A Touch of Glass." *Quest/79* 3, 6 (September 1979): 84–86.

Spring, Justin. "Dale Chihuly: Charles Cowles Gallery." *Artforum* 3, 10 (Summer 1992): 110.

Wissinger, Joanna. "Variegated Life Forms." *Metropolis* (July/August 1992): 26.

Wooster, Ann-Sargent. "Dale Chihuly: American Craft Museum and Charles Cowles Gallery, New York." *Glass Magazine* 47 (Spring 1992): 50–51.

Newspaper articles about the artist

Allen, Jane Addams. "Treasure from Hands of Master Craftsman." *The Washington Times* (5 May 1983): 2B.

Barcott, Bruce. "Chihuly: The Imperial Wizard of Glass." *Seattle Weekly* (14 November 1990): 38–45.

Cotter, Holland. "Dale Chihuly: Charles Cowles Gallery," *The New York Times* (15 January 1993): C22.

Downey, Roger. "Glass Act." *Seattle Weekly* (12 August 1992): 25–27.

Goldberger, Paul. "The New Rainbow Room: S'Wonderful." *The New York Times* (20 December 1987): Sect. 2, 40.

Hackett, Regina. "Dale Chihuly Cultivates Organically Based Forms." *Seattle Post-Intelligencer* (6 November 1991): C1, C14.

Hammel, Lisa. "The Highly Skilled Teamwork behind the Master Craftsman." *The New York Times* (29 August 1985): C1, C6.

Hollister, Paul. "Studio Glass: Works by a Master Craftsman." *The New York Times* (7 November 1985): C9.

——— . "Glass Sea Forms in Chihuly Show." *The New York Times* (2 April 1981): C11.

Kangas, Matthew. "Splendor in the Glass." *Seattle Weekly* (18 January 1989): 32.

Reif, Rita. "Chihuly's Glass Spheres are Worlds Unto Themselves." *The New York Times* (5 July 1992): 24.

Smith, Roberta. "Dale Chihuly [at Dia Art Foundation]." *The New York Times* (12 August 1988): C25.

Weinstein, Jeff. "Dale Chihuly: Il Macchia Sculptures (1985)." *The Village Voice* (26 November 1985): 114.

Zwinger, Susan. "Sea Lifes in Silicon." *The Santa Fe Reporter* (4 November 1981): 24

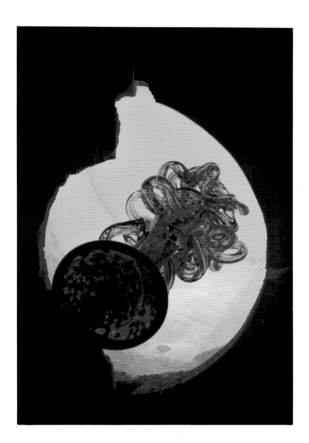